REMEMBERING
GERMANTOWN

REMEMBERING
GERMANTOWN

Sixty Years of the *Germantown Crier*

EDITED BY JUDITH CALLARD & IRVIN MILLER

Charleston | London

THE
History
PRESS

Published by The History Press
Charleston, SC 29403
www.historypress.net

First published 2008

Manufactured in the United States

ISBN 978.1.59629.516.2

Library of Congress Cataloging-in-Publication Data

Remembering Germantown / edited by Irvin Miller and Judith Callard.
p. cm.
Articles originally published in the Germantown crier between 1949 and 2008.
ISBN 978-1-59629-516-2
1. Germantown (Philadelphia, Pa.)--History--Anecdotes. 2. Philadelphia (Pa.)--History-
-Anecdotes. 3. Germantown (Philadelphia, Pa.)--Social life and customs--Anecdotes. 4.
Philadelphia (Pa.)--Social life and customs--Anecdotes. 5. Germantown (Philadelphia,
Pa.)--Biography--Anecdotes. 6. Philadelphia (Pa.)--Biography--Anecdotes. I. Miller, Irvin,
1932- II. Callard, Judith. III. Germantown crier.
F159.G3R458 2008
974.8'11--dc22

2008035235

Contents

CONTENTS

Introduction

The Germantown Historical Society (formerly the Site and Relic Society) was founded in 1901 by a group of people who had an interest in preserving the history and architecture of Germantown, Mount Airy and Chestnut Hill, which made up the original German Township. It was not until 1949, however, that they started a journal, the *Germantown* (originally *Germantowne*) *Crier*, to gather research and memories. They began by reaching back to material already published in newspaper articles and by persuading old-timers to write their reminiscences down for posterity.

At first, these stories had few footnotes (some wish the present *Crier* had fewer!) and many of them did not identify the specific time and place being written about. Early articles also covered Philadelphia and points farther afield, whereas recent articles focus solely on Germantown, Mount Airy and Chestnut Hill. Writers and editors became more rigorous in documenting their research. Readers and writers alike, however, still enjoy first-person narratives by those who live in and love Germantown.

There is never a shortage of tales to tell—of early German settlers (beginning in 1683), antislavery efforts (1688), the American Revolution (including the Battle of Germantown), the Civil War (many from here served and died), nineteenth-century suburban development and the coming of the railroads, the influx of people from many countries to Germantown's mills and businesses and the migration of African Americans north to Germantown.

Our housing runs the gamut from row houses to mansions, rich and poor often living close together. Many efforts have been made to preserve significant buildings—enough that Germantowners are always aware of their history. Here is Cliveden, site of the reenactment of part of the Battle

of Germantown every October, and here is a little restaurant that used to be home to butchers, weavers, powder makers and nurserymen. Here is Rittenhouse Town, where we walk in the woods and where paper was made in the old days. Here, next to a stop for the Germantown Avenue bus, is the Johnson House, where enslaved people were hidden on their way to freedom.

The early writers for the *Crier* had the same feelings as we do for Germantown history, especially for their own youth. People remember driving in sleighs on a crisp snowy day, learning to skate on a nearby pond, playing in the streams and meadows, eating "hokey-pokey" ice cream, seeing wild animals in traveling menageries and being shocked and awed by the arrival of the railroad and later by the new automobiles.

For many years the *Crier* came out four times a year and had a volunteer staff and committee. The editors we know of have been John W. Jackson, Katharine R. Wireman, Jane Carl, Edwin Iwanicki, John McArthur Harris, Joanna B.F. Schlechter, Helen M. Comly, Lisabeth M. Holloway, Sam Whyte and Judith Callard. They were tireless in their search for good articles and photographs and at times had artists add drawings to the articles. All the photographs used in this collection are from the Germantown Historical Society archives unless credited otherwise. We have enjoyed choosing the photos and selecting and excerpting articles from the sixty years of the *Crier* for this book. We especially thank all the contributors to the *Crier* over its sixty years. Thanks also to staff and volunteers at the Germantown Historical Society, including Eugene G. Stackhouse, J.M. Duffin and Eliza Callard, for their assistance.

We have favored personal reminiscences and short pieces—the more rigorously researched material is better seen at the Germantown Historical Society. We know that during the *Crier*'s sixty years, many a researcher has come into the library and been approached by the librarian or editor with, "How would you like to write up your research for an article in the *Crier*?" So the stories of Germantown continue to be told.

Part 1
Early Days

Old Germantown, Particularly Market Square

By Elliston P. Morris, read at a meeting of the Site and Relic Society,
April 18, 1902; published in the Crier, *1949*

As a resident of Germantown for nearly seventy years, I have much to remind me of the past and of the changes that have come over the green country town in my day. When it was made a borough, our first burgess was Samuel Harvey, who was, for so many years, president of the Bank of Germantown. He was the leading man of the old Methodist meeting, whose place of worship and congregation were as plain and unostentatious as that of the Friends. The other leading elder was Father Harmer (familiarly called) who, with his wife, I always met on their way to the Methodist gathering, as my father and myself were on our way to the old Friends meetinghouse at Main [Germantown Avenue] and Coulter Streets. The Harmers' house stood where H. Righter's plumbing shop, 5424 Main Street, now is.

Both the Methodist and Friends meetinghouses of that day have disappeared, and new and more commodious ones now accommodate much larger congregations in each, the Methodists having erected the beautiful and ornate building at the corner of Main and High Streets.

I am old enough to think that those were the halcyon days of Germantown, when a horse-car twice a day on the Philadelphia, Germantown and Norristown Railroad was the only opportunity of going to the city, except the four-horse omnibus—which started about nine o'clock in the morning for the old Rotterdam Hotel on Third Street and returned in the evening—and the four-horse Troy coach, which carried the mail to Bethlehem and passed

Market Square and my father's house about six o'clock in the morning, at which hour I often tumbled out of bed to see it go by; the coach returning in the afternoon from Bethlehem, taking the mails to and from the city.

Those were the days when everyone knew his neighbor, and tramps were unheard of; each enjoyed his own doorstep and roof-tree, and in the security and freedom of honest living the open door of the comfortable, old-fashioned homes seemed to bid a welcome to the passing stranger.

One of my early recollections is that of Benjamin Chew, who lived at Cliveden, the Chew mansion, and every Sabbath drove past my father's on his way to St. Luke's Episcopal Church in his old-fashioned Washingtonian-style coach, driven by a colored man, whilst on the rear stood another one grasping the straps. Benjamin Chew was the last, I think, in our town to wear short clothes with low shoes and buckles, and hair done up in a queue.

Octogenarians were frequently met with, and the Ashmeads, Merediths, Masons, Lehmans and Emhardts all lived within a few doors of the hall we are now in. Old John Ashmead lived next to my father and nearer the city. By him I, as a boy, was shown the spot where he saw six British soldiers brought out from [Germantown] Academy (which during the War for Independence was used as a hospital after the Battle of Germantown) and buried in one grave; he also told me that as the British forces, headed by Lord Howe, marched up from Stenton to reinforce those engaged at the Chew House, he had run to their cellar window to see them pass; afterward, when the fighting was all over, he and other boys saw the result of the battle and the wounded men.

Around this neighborhood there is much of interest. How different is the old Market Square from what it was in the days of my boyhood, and its old trees, all but one, are gone! That one, the fine buttonwood, still stands; and it is about this tree and the other trees that I have been asked to speak.

My father, Samuel B. Morris, was one of the earlier citizens to find a quiet home in Germantown. He removed here in 1834, having purchased the property from the estate of his father-in-law, Elliston Perot. He had then retired from the active business life of a shipping merchant. He was the first, perhaps, who took any interest in the care and preservation of the old Market Square, the piece of ground fronting on Church Lane and Main Street, and conceived the idea of giving it some form and shape by the use of shovel and rake and generous sowing of grass seed, then planting posts at the corner to keep the huckster and other wagons to the side next to the house, for in those days it was indeed a common, both in name and fact.

At the end farthest from the city stood an old-fashioned, seldom-used brick pier open market house, which I think was far anterior in date to the

Fellowship engine house that stood by its side, farther back from the Main Street and facing Church Lane. The latter building was rather attractive, with its little white spire. There was housed the old wooden-wheeled hand engine, brought from England in 1764 (tradition dates its building thirty years prior thereto), which is now in charge of W.H. Emhardt, and can be seen in the office of the Germantown Mutual Fire Insurance Company. By its side stood a larger hand engine of much later date, and a bucket wagon filled with leather buckets and a small reel of hose. On the front of the wagon was an artistic painting of a spread eagle with a ribbon in its mouth, bearing the inscription, "When duty calls it is ours to obey." To my boyish eyes this was a marvel, and of course I adopted the claim of being a Fellowship boy, and was as proud of its active service and prompt arrival at fires as any of its members.

But I must, as desired, give a history of the great buttonwood tree still standing on Main Street. My father planted a row of trees, some eight or ten in number, along the curb, and protected them from injury by horse or wheels by placing neatly painted wooden tree boxes around them, and waited for the time of leafy spring. But the old adage of "boys will be boys" even then held true, and so a few nights after, whilst we were at the supper

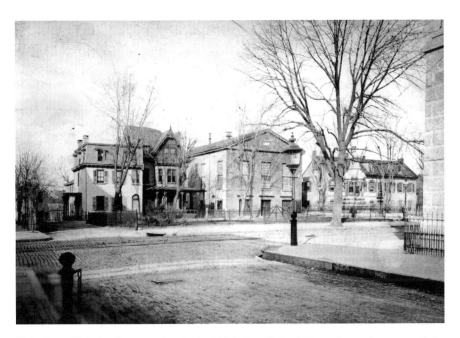

This view of Market Square, taken in the 1880s from School House Lane, shows one of the remaining large trees that were planted along Germantown Avenue.

table, frantic yells of boys met our ears, and running to the front of the house, it was still light enough to discover the cause. With the idea of stirring the wrath of my father, the gang had upended all the tree boxes, much to the risk of the trees being broken, and then run away. Not knowing what better to do, my father replaced them next day, with the same result.

Almost in despair of his cherished plan for the shade trees, my father concluded to try the use of the oiled feather, and so one evening, about the time of the usual onset, he secreted himself, unknown to the boys, behind one of the large brick pillars of the market house, and just as the ball was about to open, he stepped out with the word, "Boys!" Of course all started to run; but with his kind, persuasive manner, he succeeded in gathering them about him, assuring them that there was no impending harm. He then explained his having planted the trees and protected them by boxes and that he had done all he could for their life; that it was not for himself or his pleasure alone, but for the good of others and of the town; that he would soon pass away, but that they would live to see the trees grow and give shade; that now it was most important that some other should care for them, and he wished to put the trees under their care, as they and their children would be the ones to walk under the shade of their branches. With a "goodnight" he left the boys to cogitate. Suffice it to say, the trees were never disturbed afterward; they grew to be noble specimens and fully shaded the passersby, until, in an evil day, the great convenience of telegraph and trolley cars made their appearance, and limb after limb was cut, until death in one case after another ensued, and finally this one tree, being so near my own house, was left to tell its tale.

Not more than fifteen years ago I was walking on the main street and was joined by a gentleman who was and still is one of the foremost mechanics of our town, and as we passed beneath this tree, he said, "I often think of your father as I walk here; you remember how much he was annoyed by the boys when he planted these trees? Well, I was one of those boys; and as I pass I remember him and his words."

Some of you well remember that, in the effort for supposed improvement, the iron railing around the square was demolished, and this old tree was condemned to the woodman's axe, but it still stands on the curb in front of the square, the fight to preserve its life having been so nobly fought by the members and officers of the Site and Relic Society. There may its branches long wave in honor of the noble planter and its foster parent!

Shagrag Fire Engine

By Jeffrey C. Wise and Judith Callard; Crier, 2002

In the early days in Germantown, volunteer firefighters were required to keep two leather fire buckets in their houses at their own expense. If they were not in the correct place when an inspector visited, the fireman could be fined. The buckets were used to carry water to the water box in the fire engine. In 1764, Germantown was divided into three parts for firefighting—the Upper Ward Fire Company, the Middle Ward and the Lower Ward. In that year the Middle Ward Fire Company bought a small engine from the City of Philadelphia. The engine had been built in London in about 1730 by Newsham (or Newshan) and Rag and somehow became known as Shagrag. It was housed in a shed on Market Square in Germantown.

It was designed for use as either a suction or force engine. The body was a wooden trough five feet long, eighteen inches deep and twenty-one inches

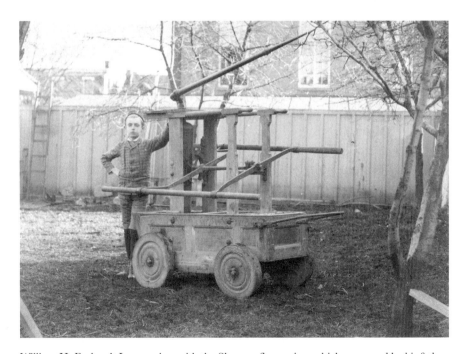

William H. Emhardt Jr., age nine, with the Shagrag fire engine, which was saved by his father.

wide, lined with copper sheathing. In the rear were two upright cylinders containing pistons. These were worked by a number of men pumping handles up and down. A moveable pipe and nozzle could be aimed at the fire. When well manned, the engine could throw a stream half an inch in diameter forty or fifty feet high. When used as a suction device, it could be opened in the bottom and a pipe could be lowered into a well or other water source and the water suctioned up to the engine.

The company acquired another engine in 1796, but Shagrag continued to be used until 1819, when it passed to the Fellowship Hose Company. By 1822, it was seen as too antiquated. Efforts to sell it for fifty dollars failed and it was resolved "not to sell the old engine." It was still used occasionally and its last appearance was in a parade in 1865.

It then passed into the hands of William H. Emhardt Sr., who kept it carefully housed at the Germantown Mutual Fire Insurance Company's building at the northeast corner of Germantown Avenue and School House Lane in the Delaplaine house. He sometimes tested it, finding that when the leather parts were wet it worked as well as ever. In 1911, his son William Jr. became president of the company at the age of thirty-five and remained so until at least 1943.

In 1946, the company moved from the Delaplaine house to the Fromberger house (now home of the Germantown Historical Society), and it may have been at this point that Shagrag was loaned to the Franklin Institute. It was there until at least 1965. It was later moved to the Fireman's Hall Museum at 147 North Second Street, Philadelphia, where it is on display to this day.

Sigillum Germanopolitanum, 1691

By Mark Frazier Lloyd; Crier, 1982

The logo of the Germantown Historical Society is the corporate seal of Germantown's independent government, founded in 1691. During the last third of the nineteenth century and the first third of the twentieth there was considerable confusion and debate as to the correct rendering of the seal. All that was known for sure was a description of the seal that was written by Francis Daniel Pastorius in a family letter in 1691. Germantown's

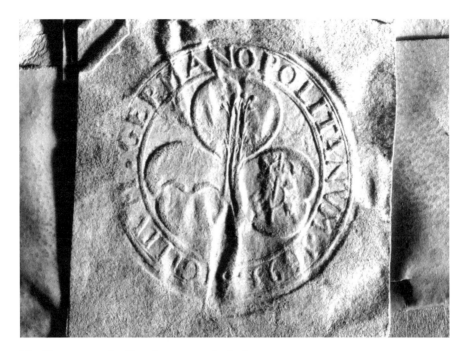

The Germantown Seal imprint on an early deed.

independent government ceased to exist in 1707. Over the course of the next 150 years, Germantowners and historians alike lost track of the seal.

When interest in old colonial Germantown sprang up in the 1870s—at the time of the centennial—Pastorius's letter was found and quoted, but no one could locate an example of the seal itself. One rendering of the seal appeared in print in 1882; another joined the first at the turn of the century. The confusion reached its peak in 1907 with the publication of the *History of Old Germantown* by Dr. Naaman H. Keyser et al. Printed on the hardbound cloth cover of this book were two seals: a "court seal" (which was the later of the two above) and a "town seal" (which was that published in 1882). As things turned out, both were faulty renderings of the original seal.

In 1932, Clarence W. Brazier, a New York architect, discovered several old deeds describing property in Germantown. These deeds were forwarded to Charles F. Jenkins, a past president of the Germantown Historical Society. Mr. Jenkins forwarded them to the secretary of the society.

What was so important about these deeds was that at least two of them were sealed with the original, corporate seal of Germantown. Coming in 1933, the year of the 250th anniversary of the founding of Germantown, this discovery produced quite a stir. Robeson Lea Perot, an architect and

president of the Germantown Historical Society, carefully copied the seal and presented a large, framed drawing to the society. The *Beehive*, the local monthly magazine named for Pastorius's own manuscript collection of writings, ran a story on the find in its July 1933 edition:

> *Pastorius, the Founder, a versatile scholar, drew the design, which he described in a letter to his father dated October 10, 1691. In this letter the Founder said: "The Council of Germantown now has a seal of its own, upon which is a trifolium having a grape vine on one leaf, a flax blossom on another, and a weaver's spool on a third, with the inscription 'Vinum, Linum et Textrinum.' This is to show that the people of the place live from grapes, flax, and trade."*
>
> *This new find is undoubtedly the work of Pastorius himself. He was unquestionably the only man of learning in the settlement, the only man with sufficient artistic ability to conceive and execute a drawing of that character. The legend "Sigillum Germanopolitanum" is proof that Pastorius had a hand in the matter. The first word is Latin and the second word is Greek. They mean in English, "Little Seal of the German City."*
>
> *In former conceptions of the seal the wine industry, represented by the grape, was portrayed by a single bunch of grapes, whereas Pastorius, as might be expected from a man of his type, drew a grapevine, described in his letter by the Latin word "vinum." In the seal as formerly published, the growing of flax, or farming, was represented by a distaff filled with thread. In the Pastorius drawing this is shown by a flax plant. Industry, or trade, as the Founder designates it, is portrayed by a weaver's spool, of the type then in use.*
>
> *The date on the seal, 1691, corresponds to the date of the letter Pastorius wrote to his father, in which he said the town council "now has a seal of its own."*

Early Days

The Potter's Field

By Eugene Glenn Stackhouse; Crier, *2003*

The Germantown Potter's Field, or Strangers Burying Ground, was located on Queen Lane between Pulaski Avenue and Priscilla Street, where the Queen Lane Apartments now stand. It was used for over 150 years for burials of "strangers, negroes, and mulattoes."

The seventh article of the preamble of the old record book of the Lower Burial Ground of Germantown, now known as the Hood Cemetery, written in 1738, states, in part: "If in case such Monies so received for the Burial of…Strangers shall prove to be any more than what will be requisite for the Use aforesaid, then such Overplus or Spare Money, shall by the said Overseers be carefully kept in order to be (when sufficient) applied for the purchasing of a Suitable Spot of Ground in Germantown for a Common Burial Place to Strangers and Negroes."

The eighth article resolves

> *that as in particular our said burying ground aforementioned contains much too little ground (Even without the Reception of any Strangers) to contain our own dead in times to come, Therefore they the said Overseers and their successors or any of them are hereby empowered and shall & may joyntly and Severally Oppose, Deny, and prevent the burying of any Negroe or Negroes or Mulattoe kind on the said Burying Ground whether such Negroe or Mullatoe may or shall belong to any Inhabitant of Germantown or to a stranger, under any Pretence whatsoever.*

This is the first known reference to what would become the Germantown Potter's Field.

The Potter's Field was officially purchased in 1755. Matthias Zimmerman, in his atlas, records,

> *The Germantown Potter's Field or Strangers Burying Ground: situate in the Lower Part of Germantown on the North West side of a Certain Public recorded Fifty foot wide Road or lane (otherwise called Bowman's Lane) and Situate about 152 perches South Westwards from the Germantown Main Street and purchased for the use of and for and as a Strangers Burying Ground or Potters Field for all Germantown to use for a Burial Place for all Strangers, Negroes and Mulattoes as Die in any part of Germantown forever, and was for the Purpose aforesaid, Purchased as part of the late*

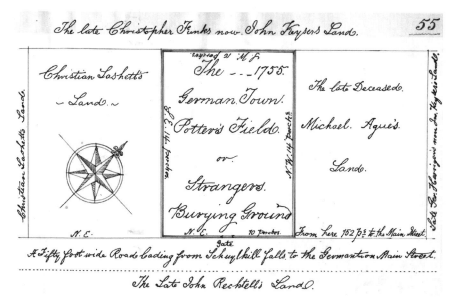

A surveyor's map of the Germantown Potter's Field or Strangers Burying Ground.

George Arnold's Estate, of Samuel Morris, Esq. The High Sheriff of the City and County of Philadelphia and Publick Auctionor Vendue by Baltes Reser for Five Pounds ten Shillings on 23rd day of July A.D. 1755.

The next record of the Potter's Field comes from the minutes of the Upper Burial Ground of Germantown from a meeting held March 24, 1766:

Occasioned by the request of Christian Warmer to bury his dead negroe child in the…burying ground. "It was unanimously Resolved by the said Inhabitants: That as a separate lot of land of sufficient largeness situate on the Northwest side in Bowman's Lane in Lower Germantown, has several years ago by the whole Germantown Inhabitants been purchased on purpose for and as a separate and distinct Burying ground for all Strangers, and negroes and mulattoes as die in any part of Germantown;—That therefore henceforth no Negro or Mulattoes shall be buried or suffered to be buried in the said upper Germantown Burying Ground nor on any part thereof on any pretence whatsoever, nor any stranger but what by the overseers of the said Burying Ground for the time being shall in their judgment and discretion…be judged suitable and be admitted to be buried in the said upper Germantown Burying Ground."

At some point, responsibility for the Potter's Field became a function of the trustees of the Lower Burial Ground. We find an entry in the old record book of the Lower Burial Ground for January 1, 1788: "Christian Laashet and Justus Fox are appointed to a Committee to settle the accompts of the Burying Ground in Bowman's Lane with Henry Sorber the present Treasurer." There are no other earlier known records regarding this supervision of the Potter's Field.

The old record book of the Lower Burial Ground also states: "At a meeting of the Trustees of the Burying Ground at the Lower End of Germantown held…January 1st, 1791…Henry Sorber was chosen Trustee of the Burying Ground in what is commonly called Bowman's Lane." Henry Sorber was again chosen trustee from 1791 through 1802 and Jacob Gardner was also chosen gravedigger for the Potter's Field. From the old record book, January 1, 1803: Jacob Gardner was chosen gravedigger and manager. January 1, 1804: Jacob Gardner is appointed manager for "the one back Riters Lane." Also, "It is further Resolved that Each & Every person Buried in the Burial ground back Riters Lane Shall pay for every grown person one Dollar Into the hands of Who Shall at the time have the Management of Said burial ground and Children shall pay half price that is 50/100."

In 1812, the Potter's Field was referred to as the "one back Wittals Lane." At the meeting of January 22, 1838, the burial ground was recorded as the "Potters Field in Indian Queen Lane."

The last reference to the Potter's Field in the old record book shows: "February I, 1860: Amount received for digging single strangers ground: $23.00."

The Lower Burial Ground was incorporated as the Hood Cemetery Company in 1867 with no mention of the Potter's Field. Sometime after this, the Germantown Poor Board took responsibility for the Potter's Field. I have found no record of this transfer of responsibility. The *Independent-Gazette*, in an article published in 1912, has the headline "Ancient Title Seems to Show that the Poor Board Has No Right to the Tract," and in 1916 the *Germantown Guide* stated, "No One Knows Who Owns Queen Lane Plot or What Shall Be Done With It." At that time, the old record book had been missing for some years and no one seems to have remembered that those caring for the Lower Burial Ground had been taking care of the Potter's Field.

In later years, the Potter's Field was described as a "desolate spot" and "littered with rubbish and broken glass." It was used as a hangout and playground by the boys in the neighborhood. When the boys were in school, "chickens, ducks and cats roamed" the lot. There were depressions throughout the ground indicating grave locations. Some graves were marked

by rough stones. In 1915, the Germantown Poor Board, in cooperation with the Germantown and Chestnut Hill Improvement Association, agreed that there would be no more burials in the Field and that plans would be made to turn the property into a playground. Occasional burials, mainly of "Negro infants," were made until 1916, when the Philadelphia Board of Health declared the Germantown Potter's Field a public nuisance.

In 1920, John T. Emlen and other members of the Society of Friends (Quakers) sponsored a survey on using the property as a playground. A playground was finally established there and was used by boys from the Wissahickon Boys Club. In 1955, a high-rise public housing project was built on the site.

The King of Prussia Inn

By George W. Williams; Crier, *1953*

The author lived in this house from 1892 until 1899. His account of it was published in the Independent-Gazette *of Germantown in 1896. In 1910, the building was demolished and a number of up-to-date stores were erected on the site.*

This old house extends its broad front along the westerly side of Germantown Avenue, between School [House] Lane and Maplewood Avenue, and takes in the numerals 5514–5522. It was built in 1740, and was converted into an inn in 1763 and named in honor of Frederick the Great, which was about the period of his last great victories. When this quaint building was erected, it was considered by the inhabitants of Philadelphia (which then did not extend much beyond Sixth and Market Streets) as being far beyond the city—in the country. Now it is in the heart of one of the city's most populous wards, the twenty-second.

Alexander McCarraher was the first proprietor of this inn [another account says it was Andrew Weckesser]. The next was Thomas Napault, and after him came Michael Riter, formerly the landlord of the Indian Queen Hotel on the corner of Indian Queen Lane (now Queen Lane) and Germantown Road (now Germantown Avenue). The Masonic fraternity then met in it. Mr. Riter was one of the founders and a member of the first board of directors of the Germantown National Bank (1814). Jacob Tripler

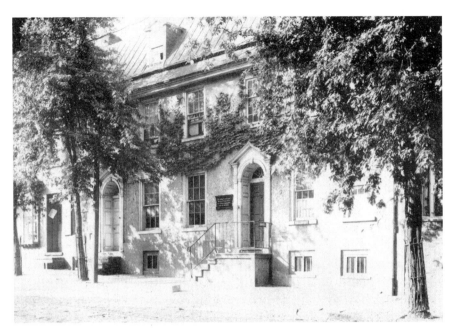

The King of Prussia Inn in the early 1900s. Beside the door is a plaque provided by the Site and Relic Society of Germantown.

was the proprietor prior to and for sometime after 1823. Abraham Shrack was the next, and the last was G. Boswell.

On the morning of the Battle of Germantown, October 4, 1777, the left wing of the British army was on School Lane and reached from Germantown Road to the Schuylkill River. This wing of the army was led by General Knyphausen, Generals Agnew and Gray being subordinate to him, as well as General Van Stern and his Hessians, while the chasseurs mounted and on foot under Colonel Van Wormbs were on the Ridge Road as far up as the Wissahickon. The officers at the Germantown end of the wing who were privileged to leave the ranks regaled themselves at its bar. In fact, on that day the enemy had complete possession of this inn.

In repairing the roof about a century after the Revolutionary War, one of the carpenters found a brass musket ball embedded in a rafter next to the lower window jamb of the first dormer window at the north end and west or rear side of the house, breast high from the garret floor. Undoubtedly a British soldier, recognized by his uniform and seen from a distance at this window, was fired at by an American sharpshooter from too great a distance to hit his mark, although the ball must have struck within a few inches of a vital spot of the Englishman. The American stood

in a westerly direction from the window when he fired. A blue coat with brass buttons of colonial days was found at the same time between the rafters. The coat fell apart while it was being handled, but the buttons were saved. Several leaden bullets and a bayonet badly rusted were also dug up from the grounds surrounding the house.

A piece of blue and white plaid silk in good condition, evidently very old and belonging to a lady's dress, was found in 1893 by the writer under a loose floorboard in the attic, along with a receipt of the Boston and Philadelphia Steam Boat-Line dated March 7, 1831; a letter dated January 27, 1832, signed Abraham Schrack; and a newspaper scrap dated July 5, 1782.

During the yellow fever epidemic in Philadelphia in 1793, Germantown was made the capital of Pennsylvania and the business of the commonwealth was transacted in a double front stone house that stood on Germantown Avenue; some of the state officials were guests at the King of Prussia Inn, which was some fifty yards above the temporary capital.

Gilbert Stuart, the famous artist, during his stay at this inn (1793–95) painted an equestrian figure of Frederick the Great on a large hanging sign for the proprietor of the inn. He desired to be unknown in the matter, but the secret was too good to keep very long and this added greatly to the popularity of the hotel in after years.

In 1832, Abraham Schrack (then proprietor) had the old sign repainted and Stuart's work of art was hidden from sight and replaced by an ordinary lettered sign. The old sign was stored in the attic with other relics. There were some very fair landscapes painted by Stuart on the walls of the drawing room. They were principally of early Pennsylvania, of the Allegheny Mountains, the Wissahickon with Indians among the trees and also some views of old Germantown. They are now (1896) covered by wallpaper.

Formerly there was a large, long stone barn in the rear, which was used by the British when they were in Germantown as a slaughterhouse. It was burned down in 1849. A frame barn of colonial days that stood near the stone one—the beams, girders and rafters of which were hewn out with an adze—had its roof and some of its contents consisting of colonial relics burned on March 5, 1896. The loss was said to be $100,000. During the yellow fever scourge in Philadelphia, President George Washington occupied the Morris House opposite Market Square. He had several horses stabled in these two barns, not having room for them all at that place. He had some twenty-two head of horses at that time.

The first stagecoach having an awning was run by Coleman from the King of Prussia Inn to the George Hotel at Second and Mulberry (Arch) Streets, Philadelphia, making three trips a week.

Early Days

Between 1825 and 1838, the circuses and menageries that came to town were located on the grounds of this inn, and during this period political mass meetings were held there.

About 1833, Benjamin Lehman's lumberyard a short distance above the inn was destroyed by fire. Two alarms brought fire companies from the city. On this occasion, all the wells in the neighborhood were pumped dry, including the two of this inn. Peach brandy was sold to the firemen and carried to them in leather fire buckets.

The Middle Ward Fire Company, one of the first in Germantown, was organized January 28, 1764. It built its first house (frame) on Market Square and held its meetings in the King of Prussia. On August 29, 1833, the firemen held a meeting here when the building committee reported the old engine house had been sold for $1,400, and a contract given for a new house for $9,500. The next year this company was known as the Washington Fire Company.

In 1838, the inn ceased to be a public house and was occupied by the then owner, William Ashmead, who had a grocery store in the southerly end. After his death his son, Charles F. Ashmead, resided in it and succeeded him in the business.

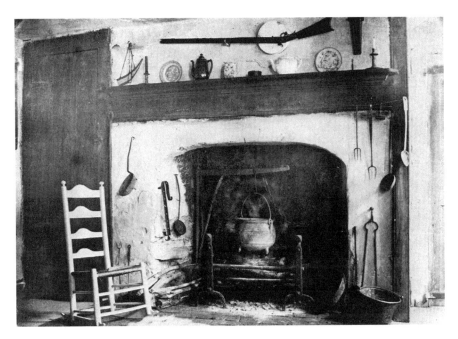

Fireplace kitchen in the basement of the King of Prussia Inn.

In 1863, a French woman was conducting a school in the former storeroom. Afterward Henry A.W. Smith occupied the store for his plumbing business. The dwelling part of the house was leased from 1865 for some twenty-odd years by Miss Horstman. During the winter of 1889–90, the family of Lewis C. Cassidy, attorney general of Pennsylvania under Governor Pattison, lived there. Since that time the author of this sketch, Dr. George W. Williams, dentist, has resided in it.

With the march of time, modern improvements have been introduced into this house, but there are many quaint features still to be found in it. In the north front cellar, which was in former times a basement kitchen, is a large fireplace with an iron crane. A door from this cellar on the north side leads to a vault in which ale and provisions were kept. Stone steps lead to a door opening into the yard. A long, narrow opening in the north wall of the vault discloses the old well where butter, meat, etc., were lowered to be kept cool.

As a private residence it is still known as the King of Prussia. With its gambrel roof and broad veranda that extends along the entire length in the rear of about seventy feet, shaded by fine old maples, its old brass door knocker, wrought-iron latches and its finely carved mantels and fireplaces, it still remains an object of interest to all lovers of the antique.

Part 2
Getting Around

The Germantown Wagon

By Cornelius Weygandt; Crier, *1956*

It is a matter of argument as to whether the Germantown wagon or Germantown wool was the more distinctive product of Germantown. I heard much of Germantown wool through the knitting of Aunt Rachel. I was toted hither and yon in a Germantown wagon in boyhood and I came to drive Mother shopping down Germantown in one as I grew older. The Germantown wagon was a development of a farm wagon, smaller than the usual Pennsylvania spring wagon, its back seat made so it could be taken out and a trunk, say, be put in to take to the railroad station. There was no cut under, so it took all out-of-doors to turn it around. In the front seat there was not too much room, your knees being close up to the dashboard. In the back seat, too, you were a bit scroughed up. It was a one-horse affair. I never knew of but one two-horse Germantown wagon. It was, however, a hardy and convenient sort of vehicle, very like what they called in New England the Dearborn wagon. It was in universal use round about Philadelphia, more of it in evidence around the city than any other sort of conveyance. The socket for the whip was in the right-hand forward corner. There was, as far back as I can remember, a delectable buffalo robe for the front seat and a lap cloth for the back seat. There was room under the back seat to stow away packages.

With thought of our own Germantown wagon comes thought of the horses that pulled it, Don first and then the old gray mare, Nellie. She came from Adams County in upstate Pennsylvania. She was a faithful, plodding

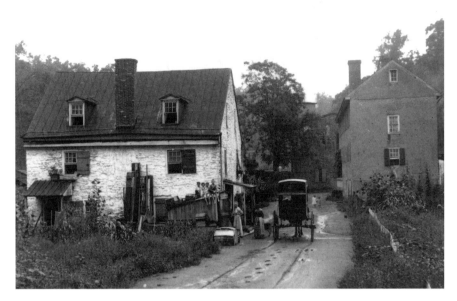

A Germantown wagon stands at Fisher's Mills (Belfield Avenue and Logan Street, formerly Fisher's Lane).

sort, afraid of nothing save flowing water seen through the planking of a bridge. We had a thrilling experience together when I was a boy of thirteen. We had just driven into the covered wooden bridge across the Schuylkill at the Falls when a thunder at the west end of the bridge ahead of us made me aware of a herd of cattle stampeding there. I just managed to back around when the white-faced steers bore down upon us. Nellie heard them too and started to gallop. They were all around us when we were out of the dark tunnel. They had dispersed by the time we reached Ridge Avenue.

I do not know what the range of the Germantown wagon was. I met them in Downingtown, West Chester and over in Jersey, but not in Reading, Harrisburg or Juniata. There were two famous makers of them in Germantown: Zell's on Rittenhouse Street, east of Greene, and one on Germantown Road below Bringhurst Street. The last one I saw came from School [House] Lane west of Wissahickon Avenue. That was as late as 1930, when the automobile was omnipresent.

Rates of Toll on the Germantown-Perkiomen Turnpike, 1801–1870

From "The Man on the Corner," Germantown Independent-Gazette, *October 1924; published in the* Crier, *1979*

Toll was authorized as follows by the act of incorporation [of the Germantown and Perkiomen Turnpike Company, 1801]: six cents for a score of sheep or hogs; twelve cents for a score of cattle; three cents for a horse and rider; six cents for a one-horse, two-wheeled sulky, chair or chaise, and nine cents if there were two horses; and twelve cents for each chariot, coach, phaeton or chaise with two horses and four wheels, and twenty cents if there were four horses. For sleighs the charge was three cents a horse, and for sleds two cents a horse. Carts and wagons were assessed according to the width of the wheels. Travelers making false statements as to the distance traveled were liable to a sixteen-dollar fine. A penalty of twenty dollars was placed on tollgate keepers who overcharged.

The tollhouse at Bethlehem Pike and Stenton Avenue in 1904. Note the tollgate raised on the right.

Vehicles whose wheels had tires less than four inches wide were not permitted to travel over the road between November 1 and March 1 with a greater weight than two and a half tons, and no vehicles were to carry more than seven tons during those months or eight tons at any other time.

The charge for two oxen drawing vehicles was the same as for one horse.

The company was required to maintain milestones, and a penalty of five dollars was made for defacing milestones.

Toll for pleasure carriages was reduced in 1849 to one and a half cents a mile, making the cost of a ride from Germantown to Philadelphia six cents.

Great-Grandmother's Flintlock Pistol

By Theodora C. Blodget; Crier, *1959*

Ann, daughter of John Frederick Junkurth, married Abraham Shermer, a tailor. He died when Ann was thirty-two, leaving six children to bring up. It was not easy for a woman in those days to get a job but Ann was both plucky and persistent. She was appointed toll keeper and had charge of the

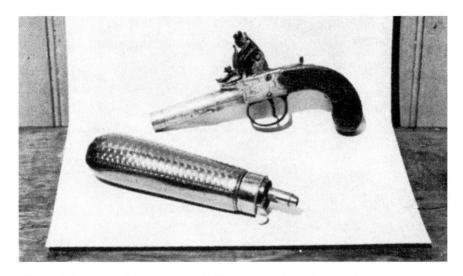

The flintlock pistol used by Ann Junkurth Shermer to enforce the collection of tolls.

tollhouse at the intersection of Bethlehem Pike and Stenton Avenue. This tollhouse was erected on a triangular strip of land that controlled both roads. It was a twenty-four-hour-a-day job. The tollhouse probably provided living quarters, which made it easier to keep her family together.

One snowy night a group of young people in a sleigh signaled to go through the gate. Ann opened it promptly and was annoyed when the party dashed through, ignoring her call for toll. She made up her mind to catch them when they came back. Early in the morning she heard the noisy party returning. She took her flintlock pistol, made sure that both gates were down and bided her time. After the driver had signaled three times, she came out, pistol in hand, and announced that she would not open the gate until they paid her for both incoming and outgoing trips. She threatened to shoot if she did not get the full amount. It was no idle threat: Pay or Shoot! They paid. The "gatecrashers" went on their way, blustering at her insistence. The victor retired to enjoy the sleep of the just.

Ann's pistol, its powder horn and bullet mold were donated to the Germantown Historical Society by her great-great-granddaughter.

Arrival of the Railroad

By Naaman H. Keyser; Crier, *1951*

Around 1829, a public meeting was held in Germantown to discuss the subject of a railroad to Philadelphia. Several gentlemen who had visited the gravity railroad at Mauch Chunk, Pennsylvania, gave a glowing account of it at this meeting. The company was organized and received its charter February 17, 1831, under the name of Philadelphia, Germantown and Norristown Railroad Company. The intention was to build the road on the west side of the town, but through the influence of Thomas R. Fisher, of "Wakefield," the route was changed to run on the east side. This necessitated bridging Germantown Road. The work on the abutments was done by a prominent mason of our town, Alexander Provest. Although heavy ironwork has replaced the light superstructure then used, the stone abutments are still standing and in a good state of preservation. The bridge is known as the Turnpike Bridge. The road started at Poplar Street

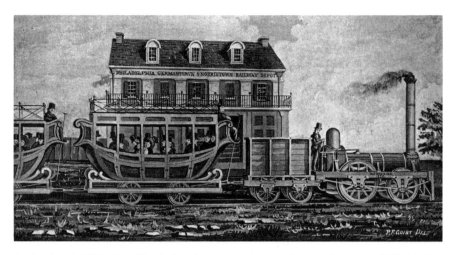

A sketch of "Old Ironsides," the first steam locomotive used on the Philadelphia, Germantown and Norristown Railroad.

and terminated at Cedar Hill, the elevation between Bringhurst Street and Shoemaker's Lane [Penn Street].

On June 6, 1832, the road was opened with great ceremony. The president, Edward H. Bonsall, had invited the councils of the city of New York to be present. The cars were made in Baltimore and were drawn by horses, six trips a day being made. The fare at first was twenty-five cents, but in 1834 it was reduced to twelve and a half cents, or as the coin was then called, a levy.

On November 23, 1832, the first locomotive manufactured in the United States, "Old Ironsides," made by Mathias W. Baldwin, was placed on the road. The contract price for the machine was $4,000. It was of an ingenious design and beset the builder with many difficulties in its construction, but as it varied slightly from the specifications, the railroad company insisted on a reduction of $500. The making of this locomotive led to the founding of Baldwin's Locomotive Works. Baldwin had so much trouble with the first locomotive that he vowed he would never build another. His second venture, however, was more successful and he afterward made considerable money, building himself a mansion on Chestnut Street, where the Randolph Theatre now stands.

In March 1833, the road was authorized to extend the single track on Ninth Street as far south as Vine Street, and to continue it to the terminal in Germantown, one hundred yards west of Main Street. When it was carried to Main Street, the tracks ran up alongside of Shingle's Tavern. Reeder's Tavern was north of it, about where Parker's store (Goodwin's) now is.

Hillary Krickbaum, a passenger on the PG and NRR who collected fares voluntarily and later became a conductor.

The rails of the first road were set on stones fastened with iron saddles, the spikes that held the cradles being soldered firmly in the stones. A number of these stones were used in the foundation walls of the Main Street station [at Price Street], and could be seen when the areaway was open in front of the building. When excavations were made in Vernon Park for the Carnegie Library, William H. Emhardt recovered one of these stones and an iron cradle and placed them in the Site and Relic Society Museum in the Concord School House.

The first two conductors appointed on the road were Joseph Kite and Daniel Dungan. There was no conductor on the first train down in the morning, so one of the passengers would collect the fares and turn in the money and tickets on arrival at Ninth and Green Streets. Hillary Krickbaum collected these fares so often that the company finally appointed him conductor of the road. This was the third appointment. John Markley was engineer of "Old Ironsides." All the coal dealers of the town had to handle their own coal cars. They were obliged to take their horses and draw the coal cars up from Nicetown planes and, when discharged, send them back by gravity. After the track was extended to Chestnut Hill, for a long while there was no telegraph communication, and should an accident or breakdown occur, one of the trainmen would be dispatched to Germantown on foot to notify the superintendent.

The company intended extending the road from Germantown to Norristown, and had so far progressed that they made numerous excavations. A deep cut was made west of Main Street, on the Wister property opposite the station. There is also one, still in evidence, behind Robert Moffley's grounds on Wayne Street, and there was another near the Wissahickon Creek. They had gone thus far when the project was abandoned because the engineers declared it to be impractical to build a bridge for railroad purposes over the Wissahickon. The excavation on the Wister property remained there until the city secured it for park purposes.

A Dazzling Spectacle

By Edward B. Phillips; Crier, *1959*

One hundred years ago next Monday, June 6, 1832, occurred one of the leading events in the history of Germantown, which resulted in changing this old borough from a struggling village into a merchandise and manufacturing center. The event was the opening for freight and passenger service of the branch of the Philadelphia, Germantown and Norristown Railroad (PG and NRR) from Ninth and Green Streets in the city to the Germantown terminal, then at Church Lane and Hancock Street, now Baynton. A couple of years ago, it was thought that the reopening of the road with its electrified equipment would take place on this centennial anniversary, but it now seems unlikely until a year hence.

But the *Telegraph*, which had a hand in advocating the construction of the road, observes the centennial by reprinting in part the account of the opening by one who was on the spot at the time, not the present business manager or the writer of this letter:

On June 6th, 1832, agreeable to arrangements previously made, the manager of the P.G. and N.R.R. opened that important work between this city and Germantown. At a very early hour crowds of people were seen flocking to the depot near Buttonwood street, Penn Township, and before eleven many thousands had assembled on foot and on horseback, and admired the splendid cars, which were placed in line along the track.

The managers of the company, the stockholders and a large number of invited guests assembled in the hall of the company's building at the eastern termination of the road. There the new Philadelphia Band in their splendid uniforms were assembled, occasionally cheering the company within and the multitude without with the excellent music. At twelve o'clock the invited guests were called to the cars appropriated for them, ranged in the following order: The Germantown, Benjamin Franklin, Robert Morris, Penn Township, Madison, Jefferson, Philadelphia, William Penn, and the President.

Following these were cars with benches for the accommodation of the band. The president and directors of the company occupied the "President." At fifteen minutes past twelve precisely, the cars began to move. Some slight difficulties were experienced, owing to the horses not being used to the work. All moved on, however, harmoniously and with sufficient rapidity to allow an occasional look at objects which had assumed a new face by the introduction of the railroad.

About one o'clock the cars arrived at the rear of Germantown. The company then alighted, the band marched to an eminence near the front carriage (now the Welsh property at Church lane and Baynton street), the top of which was now occupied by the officers of the railroad company; and after a few tunes had been played, E.H. Bonsall, Esq., the president of the board of directors, made a very interesting and pertinent address.

The company was then invited to form a procession to Mrs. Heft's tavern (possibly in the present Y.W.C.A. building) preceded by the music; here, after a few minutes' waiting they were invited into a hall, where had been prepared a sumptuous repast. A few minutes after three o'clock the company took up the line of march to the cars, marshaled by Captain Miles, who, during the day, showed the advantage of military knowledge, even in organizing a company of travelers.

At half past three the cars started for their return trip and were a little more than half an hour in performing the distance of six or seven miles. The carriages or cars are splendidly made and finished and will carry about twenty passengers inside and fifteen or sixteen outside; they are drawn by one horse in shafts between the rails. The labors of the animals were much greater on the opening day than they will be hereafter. The friction of the axles is now very great, and the pathway is quite rough. These matters will correct themselves shortly.

During the progress of the cars both ways, but especially returning, they were greeted with the hearty cheers of thousands who were gazing with anxious curiosity at these strangers. Each promontory, elevated point, and near window was occupied with the curious; age seized its staff and flourished it exultingly; childhood forwent its toys to witness the novelty; youth poured out its exuberant spirits in huzzas; and beauty unveiled itself, that no part of the exhibition might pass unseen.

The hat was flourished, labor swung its spade and mattock, the boys shouted, and the girls waved their handkerchiefs in hearty felicitation and good wishes. We looked out upon one gray-headed dame who joined the joyous group and shook her withered arm in paralytic ecstasy of pleasure; and just then we caught the eye of a black-eyed damsel, whose festive face beamed forth a smile of heartfelt delight—but she was looking at a young man on top of our carriage. (Poor old misguided reporter.)

Almost every profession and employment had a goodly representation in the company. It is due from the invited guest to the board of directors to say that every exertion was made, and successfully made, to insure the enjoyment of the visitors, whose admiration was warmly expressed, as were their hearty wishes for the success of the railroad.

The writer learned from other sources that at the Church Lane terminal stands and stalls were erected from which were sold soft drinks, pies, lunches, peanuts, popcorn and other delicacies of the season. They did a good business but paid more for rent of the ground upon which their stalls were erected than the ground was worth at that time.

The First Sidewalks

Crier, *1971*

In the spring of 1834—about 137 years ago—the citizens of Germantown were disturbed. Not that being disturbed was a novelty to the town, for only a few months before it had had quite an excitement over the question of borough incorporation, which had come to nothing, but had left some strained nerves that were the more easily excited when the legislature passed a bill making it obligatory that all properties along the Main Street, from the "5th milestone to Tullinger's Lane," should be improved with stone or brick sidewalks properly graded. The fifth milestone was at Germantown Avenue above School House Lane. Tullinger's Lane became Carpenter Street, which is west of Germantown Avenue. For 150 years, Germantown had been content with simple paths made by the many foot passengers at any level that happened to be convenient.

So the bill created an innovation, and like most innovations it found numerous objectors. It was a large undertaking for the quiet village, made none the more bearable because the expense of construction was to be paid from a special taxation in the district named. The local paper of that day said, "It must be acknowledged for every person who reads the bill with attention, that it is a very lame affair—unmeaning and indefinite—and contains within itself the seeds of confusion and litigation. As far as we are informed we believe that it meets with but little favor in any quarter."

The bill provided that the citizens were to elect commissioners whose duty it was to grade and otherwise prepare the sidewalks, and who were immediately to proceed to levy a tax on the taxable inhabitants residing on, and the property fronting on, the Germantown-Perkiomen Turnpike road, in the same ratio as the road tax of the year 1833, to be collected in the

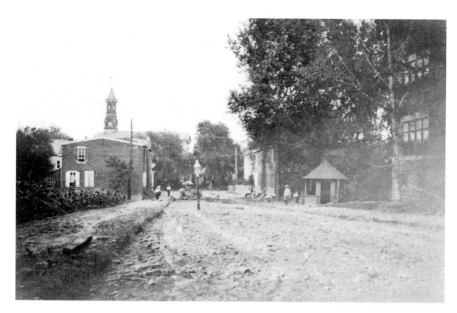

A side street in Germantown showing the muddy street and sidewalks.

same manner and at the same time as the said road tax. The commissioners were to be elected for one year only, and their duties were to be completed within that time. The road tax, however, was usually not collected until the latter part of the year—where was money to come from in the meantime? Any person who neglected or refused to serve, if elected commissioner, was to pay a fine of twenty dollars, no matter what excuse he might have. One of the commissioners was to act as treasurer—without bond or other security—and at the end of his term was to pay over all balances remaining in his hands to the supervisor of the Lower Ward, to be appropriated by him to the repair of the sidewalks in following years. Would the commissioners be likely to allow any balance to remain? After the year's term had expired, the cost of repairs was to be defrayed out of the yearly road tax, thus making the whole township liable for the upkeep of the Main Street sidewalks.

When all preparations were completed, the owner of each property was—within two months thereafter—to "cause to be laid a pavement of flat stone, brick or other hard material, at least five feet wide from the wall or curb of said turnpike road," and in case of failure to so do, the commissioners could lay such pavement and charge the cost against said property.

The citizens of the outside districts of the township felt the injustice of the upkeep tax, while those of the districts named in the bill felt that, had they been granted borough incorporation, the entire matter could more

satisfactorily have been handled by the borough officers. It was not the introduction of sidewalks that irritated so much as the methods. Moreover, no provision was made for sidewalks upon the side streets, and, without a borough organization, no grading could be done upon them, even had the individual owners desired it. Such owners, of course, did not pay the special tax, although they could enjoy the improvements on the Main Street (Germantown Avenue).

The opposition was great, but the law had been passed and its various directions had to be obeyed. By August, the work was about finished and the pavements laid. Then arose a new question. "How," asks a citizen in a letter to the *Telegraph*, "are we to possess the full benefit of our foot pavements, while we shall have to cross over the unpaved public crossing streets?" He then suggested that the large flat stones lately used as curbstones, which could be bought undressed for thirty cents a running foot, would, if laid flat side up, make excellent crossings at a cost of nine dollars for a thirty-foot street. He also suggested that the township—the outside districts of which had paid nothing toward the grading tax—should bear the expense of the crossing stones. There was a bad place at the Market Square, which had no private owner and as yet had not been graded or paved, which also might justly be done by the township or possibly by public subscription. All these additional improvements had to wait, however, and for quite a long time.

Soon it was seen that the new sidewalks were a very great aid to the comfort of pedestrians and to the appearance of the town. Complaints stopped and letters of commendation began to reach the *Telegraph* office. One writer, who convincingly signed himself "Nous le verrons," reported,

> *Every passing stranger may be heard commending our new sidewalks as beginning a new era for Germantown. This measure may stimulate us soon to another desirable change, the renewing and embellishing of the fronts of our antiquated somber stone walls—many of which look more like the gloomy prison than the light, airy residence of free citizens! We hope that those who may not choose to plaster them, will give them a face of whitewash colored with any light colored pigment. Such improvements will well repay the owners by an increase of value, or of revenue in the way of rents. Already there are more houses claimed for summer residents than we can provide, and next year there will be many more. The cheapness and convenience of the railroad is about to make the healthy heights of Germantown a place of special preference for Philadelphians.*

Thus Germantown got its first sidewalks, and perhaps too its second impetus to real town growth—the first, of course, being the railroad. The wish to brighten up the somber prison walls by means of tinted whitewash has fortunately long since ceased to be in evidence. The square-cut stone front walls, in their natural colors, of houses built in the eighteenth century are the pride of Germantown today. So far as known like the "Green Tree," Keyser and Johnson were never whitewashed. Those that were plastered or colored were rarely of the "square-cut" order, although there have been a few examples.

Streets of My Youth

By John McArthur Harris Jr.; Crier, *1979*

Greene Street and Germantown Avenue were the two main roads of my youthful existence. For years the way to school was down Greene Street, and in the early days the going was rough. The street was not paved and Hughie, Grandmother's coachman, always referred to it as "Mud Street." He was clever at dodging the deepest mudholes, with the assistance of Hannah, the mare, who also disliked them. Looking back over the continuing scene, I realize that I have walked, ridden in a horse-drawn carriage, ridden a runaway horse, bicycled, roller skated and automobiled on Greene Street. Furthermore, there have been occasions when others have ice skated and skied to school on Greene Street.

Germantown Avenue, the other main axis, became familiar territory from Walnut Lane to Coulter Street because we went to school in the trolleys when the weather made it necessary. The trolleys had four wheels and, in the summer, open platforms fore and aft. The crew consisted of a motorman and a conductor. The motorman operated the vehicles from the front platform and must have suffered during the summer rainstorms. The conductor took your fare, a nickel, and helped the elderly passengers. As the internal combustion engine developed, competition from automobiles and buses made improvements in trolleys imperative and they gradually developed into the sophisticated vehicle of the present. Nevertheless, I believe the trolley line on Germantown Avenue is one of the few remaining. During the recent repaving of the Chestnut Hill section of Germantown Avenue, it was

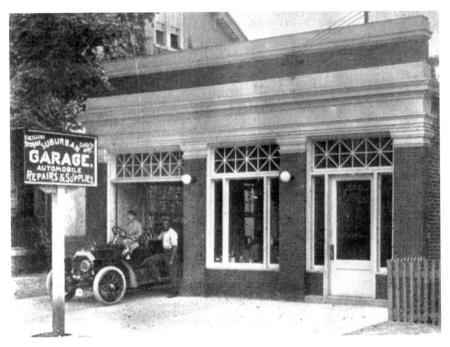

The servicing of early automobiles took place at 27 West Harvey Street in Germantown, formerly a wheelwright shop.

necessary to lay new rails for the trolley. They were obtained from Germany. Trolley rails are no longer rolled in this country.

All the adjectives known to mankind were applied to the early automobile and one can be certain that many vocabularies were enriched by sudden demands for adequate words. A neighbor on Walnut Lane owned the first automobile of which I was aware. I think it was a Reo. It actually was what, up to that time, had been called a buggy. This one had four big buggy wheels, about three feet in diameter, and a single seat running crosswise, on which two passengers could perch in precarious apprehension. The engine was under the seat and its shaft terminated in sprockets on both sides of the car. There were chains, similar to the chains on bicycles, from these sprockets to sprockets on the rear axle. My neighbor kept this contraption in his barn and, in driving it from the barn out onto Walnut Lane, he met his first problem: the curbstone. Crossing the curbstone involved a drop of four inches or thereabouts and this always stopped the engine. The car then had to be pushed clear of the curb and cranked. Of course differentials were nonexistent and turning corners caused competition between the two rear drive wheels, which sometimes caused the loss of a tire.

The proverbial rich uncle gave my father a 1904 model Packard. It had no windshield, two big, brass, acetylene headlights and a cloth top that was up or down depending on the weather. The back seat was about six inches above the front seat and could be entered by a door in the middle of the back. It held three people and the unlucky passenger in the middle sat on a jump seat hinged to the door. We always wondered what would happen to the middle passenger if the door flew open—it never did. There were no spare parts and the roads were so poor that broken springs were frequent. Many of our rides ended in the blacksmith shop. The 1904 Packard was rapidly leading the family to the poorhouse, so Father sold it and bought a sofa for the library with the proceeds.

Driving the Dinkys

By Sidney Harold Kendrick; Crier, *1981*

Our father brought his family over from England in 1909, and we went to live on the old Pratt estate near the tannery on Phil-Ellena Street. Meehan's nursery was just two blocks away on Musgrave Street. We had an outside toilet and gas, not electricity—you put a quarter in the meter for gas—and I went to the old Andrew G. Curtin School when it was a little brick building at Phil-Ellena and Musgrave.

My father got a job as motorman for the PRT. He drove the four-wheeled trolley cars they called "dinkys." They were electrified by then, but were the same old cars that had been pulled by four horses, except when they were coming up Naglee's Hill from Wayne Junction. Then they put on an extra pair, six horses in all. By the time my father was driving, the dinkys had overhead electric lines, as they do now. The power station was near the corner of Willow Grove Avenue.

The dinkys had platforms in front and back for the motorman, who sat outside, exposed to the weather, with only a roof to protect him. The dinkys could go forward or backward; at the end of the line the motorman walked around to the other end of the car and started up. You could get seasick on those cars—there were no springs. The tracks were the same tracks in use today. It took an hour and a half to get from Mount Airy to Market Street.

Getting Around

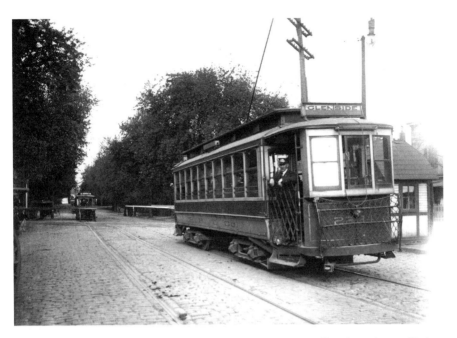

A later version of a trolley car with enclosed platforms seen at a railroad crossing on Chelten Avenue. In the front is the fishing net attachment for catching wayward pedestrians.

If anyone was on the tracks too close for the motorman to stop he could let down a sort of cowcatcher, an iron frame with a fishing net attached; it caught up the person from in front of the wheels.

Motormen made eighteen cents an hour, and in those days kids worked after school to help the family. I worked as a soda jerk for Sontag the druggist; he told me to eat all the ice cream I could hold. I did, but after the first week I never touched it; he knew what he was doing. And I drove a horse and wagon for Merkel the butcher. Actually he had two horses. He didn't like to have them out too long, so I drove Bess in the morning and the other horse, a real mean one, in the afternoon. He told me never to use the whip, but one afternoon the mean horse acted up, so I had to, and he bolted. He ran all the way home; I had to let him have the reins, I couldn't stop him. So Merkel told me I'd mistreated his horse and to get out of his sight. That was the end of that job.

Later I drove a T-model delivery truck for Tourison the hardware man. (His brother built the Sedgwick Theater between Durham Street and Mount Airy on the east side of Germantown Avenue.) Tourison could play hymns on his automobile horn. When he raced the motor, the horn on the old T-model went up in pitch, and went down when he slowed up.

You always kicked the tires before you started out because tires were good for about fifty miles in those days. On a long trip you'd carry four or five extras. Seibling finally came out with a tire good for three thousand miles.

Pelham's Auto Club

By Patricia A. Henning; Crier, *1986*

A decade after the first Pelham houses were constructed, a group of men from the community established the Automobile Club of Germantown, Pelham's first and, to this date, only social institution.

In 1905, the club's first year of operation, the automobile was still looked upon as a rich man's toy. There were fewer than five hundred cars registered in Philadelphia. For reliable transportation from their center-city offices, Pelham commuters used the trains on the Pennsylvania Railroad's Chestnut Hill line. On the trip home, club members would often meet at the clubhouse, conveniently located across the street from the Carpenter Lane station.

An application for incorporation, signed by twenty-one Pelham residents and three men from other parts of Germantown, was submitted in January 1904 and granted in March of the same year. By May, a building permit had been secured from the city to erect a clubhouse and garage on a half-acre lot at the corner of Carpenter Lane and Emlen Street. The plans were drawn up by Germantown architect Joseph M. Huston, to cost $11,000.

Huston had designed at least one other Pelham building, a house at 133 Pelham Road, which had been built for Cyrus Mead and which in 1904 was occupied by Harry K. Duffus, one of the original members of the club's board of governors. For the club, Huston designed an imposing structure with several spacious rooms and galleries to accommodate large social functions, as well as a number of smaller card rooms, pool and billiard rooms and a bowling alley. Lounge areas were provided for female guests. The club garage contained storage space for up to twenty-four cars and boasted a well-equipped repair shop manned by a competent mechanic.

In granting permission for construction of the clubhouse and garage, the owners and developers of Pelham waived a rule restricting nonresidential facilities to Germantown Avenue.

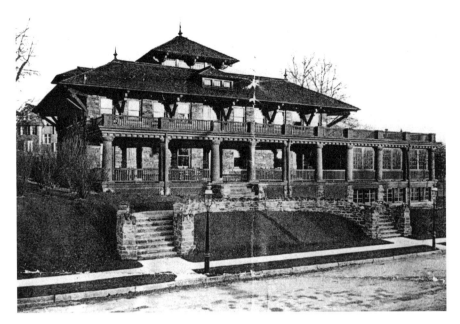

The clubhouse of the Automobile Club of Germantown. The entrance to the twenty-four-car garage is to the right.

Some contemporary newspaper accounts state that the Automobile Club of Germantown was the first auto club established in the Philadelphia area. The club's dual purpose, as stated in the charter, was "to maintain facilities for the practice and development of the sport of automobiling and other innocent or athletic sports; to maintain a club for social intercourse and to stimulate and develop social intercourse among its members." Among the original committees established to conduct the affairs of the club were an entertainment committee, runs and tours committee and a bowling committee. Before long there were also committees for tennis, billiards and pool, and the runs and tours committee seems to have been replaced by a more general committee for automobile affairs.

Membership in the club was limited to "male persons of the age of 21 years and of good character." Three classes of membership were provided in the bylaws: resident—limited to 150 in number; nonresident—restricted to persons residing outside a twenty-five-mile radius from the clubhouse; and honorary—elected by the board of governors. In 1911, architect Joseph M. Huston was among four honorary members on the club's membership list. That was the same year in which Huston was sentenced to serve a term of six months to two years in the Eastern State Penitentiary for complicity in defrauding the State of Pennsylvania in the erection of the capitol building

in Harrisburg. Huston had been the capitol architect. The other honorary members were Reverend R.P.D. Bennet of Summit Presbyterian Church, Reverend John Calhoun of the Mount Airy Presbyterian Church and Reverend Richard J. Morris of the Church of the Epiphany.

With few exceptions, the club drew its membership from the Pelham area. Of the original twenty-four subscribers, only three were not Pelham residents, and the 1905 list of members includes fewer than 10 percent who did not reside within walking distance of the club. Two of the non-Pelhamites among the founding members were William E. Helme of St. Davids, the partner of Pelham resident John O. McIlhenny in the firm of Helme & McIlhenny, manufacturers of gas meters; and photographer Prescott Adamson, who served as the club's first president.

According to an account of the club's earlier years that appeared in the January 1910 issue of *Philadelphia Suburban Life*, the idea for the club originated with a small group of men who stored their cars in the old firehouse on Germantown Avenue. Most likely this would have been 6825 Germantown Avenue, which was a firehouse until the late 1890s, when a new station was built across the street. This group included Adamson; Stephen B. Ferguson of the 7100 block of Boyer Street; Alexander M. Benson, 6733 Emlen; Harry K. Duffus, 133 Pelham; Robert Hooper, 138 Carpenter; Mark B. Reeves, 141 Phil-Ellena; and Harry W. Butterworth, 123 Pelham.

The time and circumstances of the club's demise are not known. However, a report that appeared in the August 1, 1943 issue of the Philadelphia *Evening Bulletin* states that the "Pelham Club property at the southeast corner of Carpenter Lane and Emlen Street…has been sold by the Girard Trust Co., trustee, to Harry Ross, for $28,000." Mr. Ross operated the Ross House, a restaurant and catering service, at that location. Advertisements appearing in the mid-1950s boast of "facilities for up to 700 guests in six spacious dining-rooms." It is also reported that a part of the premises was used as the first home of the Germantown Jewish Centre. Now the property serves as the Commodore Barry Club, headquarters for several Irish-American cultural groups.

Part 3

The Civil War

Germantown's Share in the Civil War

This article was first published in the Germantown Independent-Gazette, *Friday, February 17, 1911, and reprinted in the* Crier *in 1969. It was written by N.K. Ployd, one of Germantown's Civil War veterans.*

In the war for the Union, Germantown rendered glorious services for the preservation of the country. After the storming of Fort Sumter, here in Germantown drilling and recruiting commenced in earnest and in a short time two full companies of brave men were at the service of Governor Andrew G. Curtin. One company was commanded by Captain J. Reeside White, the other by Captain Hubbs. Both companies were hurried forward to protect important points and both rendered heroic service. At the expiration of the three months' term of service, all reenlisted for the war.

"Charley" Bringhurst and "Billy" Weitzman, of Lower Germantown, made a gallant fight at Sumter and throughout the war.

Two full companies were then recruited for the 95th Pennsylvania Regiment, known as Goslin's Zouaves, and were commanded by Captains Hubbs and McCollough. One full company was raised for the 106th Pennsylvania Regiment, commanded by Captain F.H. Achuff; two companies for the 150th Pennsylvania (Bucktails), commanded by Captain Jones and Captain Widdis; one company for the Pennsylvania Reserves, commanded by Captains Harkins and Stanton; one company for the 3rd New Jersey Volunteers, commanded by Captain Mark Collet; one company for the 114th Pennsylvania (Collis Zouaves), commanded by Captain Frank Elliott; one for the 109th Pennsylvania, commanded by Captain Farnsworth;

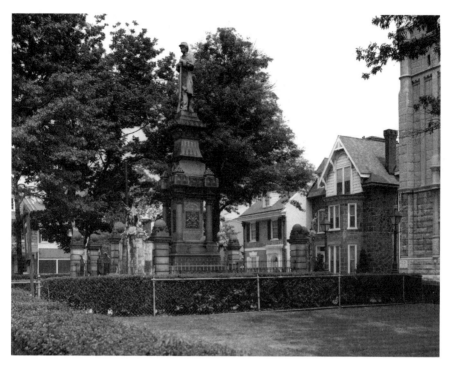

This Civil War monument in Market Square, promoted by the Ellis Post No. 6 of the Grand Army of the Republic, was dedicated in 1883.

and one for the 147th Pennsylvania (White Star), commanded by Captain A.S. Tourison.

Hundreds from Germantown joined other organizations, including the 3rd, 5th, 6th and 15th Pennsylvania Cavalry; the 11th Pennsylvania Infantry; and the 22nd, 23rd, 24th, 28th, 68th, 69th, 71st, 72nd, 89th, 90th, 99th, 118th, 119th and 121st Regiments.

General William J. Palmer, a citizen of Germantown, commanded the Fifteenth Pennsylvania Cavalry, known as the Anderson Cavalry. He, with his gallant boys, served with distinction throughout the war. General Palmer was awarded the Congress medal for his charge at Red Hill, Alabama, June 14, 1865, when, with fewer than two hundred men, he defeated a superior force of the enemy, capturing their field pieces and one hundred prisoners. Several Germantown boys were connected with his regiment, including H.A. Buzby, William Bennis, Abraham R. Thomas, Samuel Green and Samuel Topham.

Three full companies were raised for emergency regiments by the Union League of Germantown to serve for state protection. Many enlisted in the

naval service. The old fire department was largely represented in Birney's and Baxter's Zouave regiments. The various Germantown churches and schools contributed liberally of money and men for the war. St. Stephen's Methodist Church and Sunday school, for example, gave seventy-five members. Only one aged male member remained in the choir. The Sunday school gave nearly all its male teachers, their places being filled by devoted mothers, daughters and sisters.

Every organization in Germantown gave its most active members to serve under President Lincoln. The many shoe shops gave nearly all their men and boys and some shops closed indefinitely. Haines Street not only gave its quota in the war of the Revolution and the war of 1812 and Mexico, but also sent over one hundred men and boys to fight under Father Abraham in defense of the Union. Some of the old Haines Street families gave all their male members. Many of them fell in the cause or received wounds and disease to carry to their grave.

Many families sent two members, while others sent six. Among the number who gave three were the Achuffs, Whites, Wolfs, Ellises, Carpenters, Redifers, Shrivers, Boices, Schaeffers, Bussingers, Byrams, Elvidges, Ployds, Lants, Cooleys and many others. Among the families who sent four to war were the Karsners, Wisters, Keysers, Colloms and Rorers, and the Waterhouse families sent five boys, as did the McCanns, Goodmans, Newhalls, Kepharts and others. The Nielson-McMurtrie family had the largest representation: six loyal sons being in the field.

Three of the McCann family went down to death, as did the three White brothers. The two gallant sons of Mother Nice fell at Gettysburg, as did the brave lieutenant William Tourison, who commanded a company in the 147th Regiment, formerly commanded by his father, Captain A.S. Tourison, one of the bravest soldiers of the Mexican War and in the war for the Union. Lieutenant C.P. Keyser and Corporal Samuel Keyser fell at Gettysburg.

The Ellis family of Lower Germantown came from England in 1842. No better evidence of their love for their adopted country is needed than that the father and three sons answered Lincoln's call and served faithfully. The lamented John Ellis was the first from Germantown to fall. The death of this patriot caused a gloom throughout the town. Ellis Post, No. 6, was named after this loyal soldier, and his picture graces the wall of the post room.

In and around Washington, our boys rendered good service; on the fields of the peninsula many perished; they fought and fell with Baker at Ball's Bluff; at Antietam they were in the front ranks; at Fredericksburg they charged the enemy and were the last to leave the field; at Chancellorsville many fell; at the crossing of the Rappahannock they were among the first to

enter the pontoon boats; at Salem Heights, with the gallant Sedgwick, they only yielded when shot down; at Gettysburg every field received the blood of Germantown heroes; at Culp's Hill they fought desperately and were victorious; on the old McPherson farm, under the gallant Reynolds, our Bucktails fought overwhelming numbers and the fields were covered with their dead and wounded so that when night came fewer than one hundred Bucktails were present on Cemetery Hill under Captain Jones, now Major Jones, an honored citizen of old Germantown. These few survivors were hurried to Bloody Angle, where the gallant Meade and Hancock made a most determined fight for victory or for death. Death came to several Bucktails. Among the number were Harry Morris, Alfred Lees and Durborrow. Here Jacob Keyser and others received wounds to carry to the grave.

At Sherfy's farm, the Germantown Zouave company, under Captain John Waterhouse, paid a heavy penalty for their devotion to their country. Captain Waterhouse was left on that bloody field for dead, but a kind providence spared him for further usefulness.

At Cemetery Hill, when Howard was almost crushed, he called for part of his old command and the gallant Hancock, "the superb," hurried the Germantown company connected with the 106th Pennsylvania, under Captain Townsend, to their old commander. A little granite marker standing at the old stone wall tells its own story.

Brave boys from Germantown were with the gallant Pennsylvania Reserves on the Round Top and in their charges over the Valley of Death at Gettysburg. They were with Sheridan and Pleasanton; they were with Sherman on his "March to the Sea"; they were with Hooker at Lookout Mountain; at Missionary Ridge; at Peach Tree Creek. Yes, they went through all the struggles to Appomattox, and those who survived the years of trials and sufferings had the pleasure of living in a "reunited country with one flag."

Many of our brave boys suffered and died in Confederate prisons, including Andersonville, Libby, Belle Isle and Sallsbury. Yet we have a few survivors with us who stood the ordeal nobly, men like Abraham R. Thomas, William Kephart, D.W. Bussinger, Gavin Nielson, Hobard Dodd, Melville H. Freas, Adam Sanderson, Daniel Lennon, Frank H. Elvidge, John Hausman and a few others just as devoted to their country.

The Collis's Zouave Band, composed of brave Germantown boys under Captain Frank Rausher, was captured at Fredericksburg and imprisoned at Libby. Only a few survived.

At the town hall and surroundings was established one of the best army hospitals in the country. Here hundreds of sick and wounded soldiers

William Kephart (1836–1912), who served as a private in Company F of the 106th Pennsylvania Volunteers during the Civil War.

received the kindest attention from skilled surgeons and capable nurses. The name of Mrs. Collins, the faithful matron, is not forgotten. Mrs. Harvey Thomas and her sister rendered great assistance at the hospital, as did Mrs. Reuben Keyser, Mrs. Gammerie, Mrs. Fraley and a host of other faithful Germantown women. Every loyal woman in the town rendered some service in the trying days of the war for the Union. When the first gun was fired at Sumter busy hands, prompted by saddened hearts, were scraping lint or making bandages, etc.

Miss Clara Jones (now Mrs. Dye) rendered glorious service throughout the war. The writer met her at the front bringing a cargo of food for the famishing soldiers. As a volunteer nurse, she was second to none. She ministered to the temporal as well as the spiritual wants of the dying soldiers, whether they wore the blue or the gray, and performed the last rites at the graves of the fallen heroes. This woman of God was a blessing in the army camp and at the hospitals. Yes, God spared her for a great work here, where she is always ready to minister to the sick and dying just as she ministered in 1861–65. Most of our faithful women were grand workers in the Christian and sanitary commissions and "their works do follow them."

The Legacy of Cuyler Army Hospital

By Kit Schoff and Margaret Halsey; Crier, *1963*

Here in Germantown, it had been only a year since the pastoral landscape had quickened patriotically under army boots, as the young men of the town drilled to fight for President Lincoln and "Union forever, hurrah, boys, hurrah."

Some of them were to come back, after that first year of Civil War, only as casualties in the obituary columns of the *Germantown Independent-Gazette*. Others returned wounded, to the Cuyler Army Hospital that had been town hall when they left. Now, in 1862, it had room for 630 Union soldiers, because two frame wings had been put on the original building, which stood to the rear of present-day town hall.

In front of town hall, on fine days, convalescents sunned themselves on benches along the brick walk that led up to the hospital door from Main

The Civil War

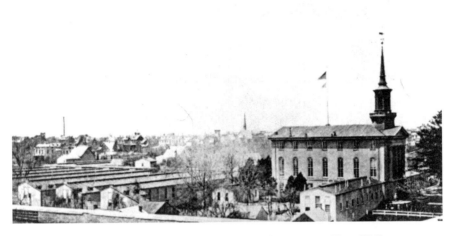

The buildings of Cuyler Army Hospital stand behind Germantown Town Hall.

Street. They presented an affecting tableau for townspeople descended from humanitarian Quaker and Mennonite stock. It was Germantown's first experience with mass care of the sick, for the nearest hospital was then in Philadelphia—a tiresome carriage ride away.

While Clara Barton created her "Angel of the Battlefield" image at the front, Germantown women found their own challenge on the homefront. They became active in the life of Cuyler Hospital, organizing a contribution room and supplying delicacies every day to the patients. Local women also organized the Germantown Field Hospital Association in July 1863, using the old Union League Building at Main Street near Chelten Avenue. This group collected and dispersed clothing and medical supplies to a broad area around Germantown.

The habit of local organized compassion persisted after the Cuyler Army Hospital closed in 1863. In September of that very year, doctors and other leading citizens met and planned a dispensary for the town's poor and needy. It was first opened that December, in rented rooms at 5438 Main Street. Two years later, the Germantown Dispensary gravitated back to the medical atmosphere of town hall, where a suite of rooms was rented for $100 a year. The managers believed it would afford "a central and commodious and permanent location."

In its salad days, the green, young dispensary was open from three to four o'clock in the afternoon each day, except Sunday; the attending physician drew the munificent salary of $100 a year, and a box of pills could be had for $0.10. In its first year, 364 people received medical advice and medicines.

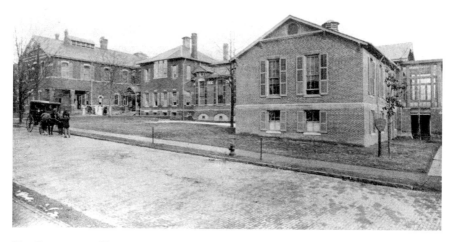

The Germantown Hospital and Dispensary on Penn Street, circa 1897.

To this Germantown Dispensary at town hall came the woman who was to be the founder of Germantown Hospital—Mrs. Pauline E. Henry, a young doctor's widow. Motivated by her dispensary work, she asked her financial advisor, F. Mortimer Lewis, and her doctor, Owen J. Wister, to help her start the Germantown Hospital in her husband's memory. In November of 1869, Mrs. Henry gave both land and building.

Mower Civil War General Hospital

By Sanford P. Sher; Crier, 2000

The United States Civil War was the most costly ever engaged in by the United States in terms of death and casualties. At the beginning of the war, the state of medicine in both the North and the South was quite primitive. Although some forms of anesthesia were used, sanitary conditions were appalling. There are reliable stories of small mountains of arms and legs piling up alongside the surgeon's tent, because of the destructive power of the new weapons such as Minié balls.

The Civil War

The same filthy clothing was used throughout these operations. Wards were unsanitary and were infested with maggots and lice. A reform of medical care was begun by the U.S. Sanitary Commission (USSC) to improve sanitation and treatment of the wounded. Medical inspections of camps were undertaken with marked improvements to patient care. The USSC undertook to meet medical emergencies and the needs of the soldiers.

At the same time, the Surgeon General's Office began a reform of army hospitals for long-term treatment and convalescence. John MacArthur Jr., one of the outstanding architects of his time and the designer of Philadelphia City Hall, laid out the plan for Mower Hospital and twenty-four other temporary army hospitals. His plan for Mower Hospital was later adopted in Germany as a barracks hospital and as an epidemic hospital in Berlin. Pavilion hospitals, as they were known, could shelter thousands of patients and the spread of infection and contamination was limited by the small number of patients (about one hundred beds) on each ward. The hospital in Chestnut Hill was named for Thomas Mower, a pioneer army surgeon.

Mower Hospital, the largest general hospital in the North, occupied a tract of twenty-seven acres between the Reading Railroad and County Line Road (Stenton Avenue), about nine miles from Philadelphia. Its entrance was at the present Wyndmoor Station of the SEPTA R7 line, and it stretched between Abington and Springfield Avenues. The hospital was built at the highest level point in Philadelphia. Pure water was obtained from the Chestnut Hill Water Company, whose water tower still exists as a historic landmark in Chestnut Hill.

The hospital of 3,600 beds was laid out so logically that it was possible to trace a patient from arrival to discharge. The patient would arrive by train—the hospital was built alongside the Chestnut Hill line of the Reading Railroad. Following admission, the patient was assigned to one of the fifty wards, each 175 feet long, radiating from a central corridor like spokes of a wheel. Tramways extended along the corridor to carry food and supplies. The water supply was drawn into four tanks having a capacity of eighteen thousand gallons each. The outflow was used to flush wastewater. Necessary services such as kitchens, power plants, dining rooms, chapel, library and operating rooms were grouped in the central open space. A large bandstand existed on the hospital grounds to provide musical diversion. There was also no lack of kindly attention by the neighboring residents, who provided cards, stationery, books and treats such as oranges and lemons.

The total number of admissions was 20,595. Of these, 9,799 returned to duty, 1,363 were discharged and only 257 died.

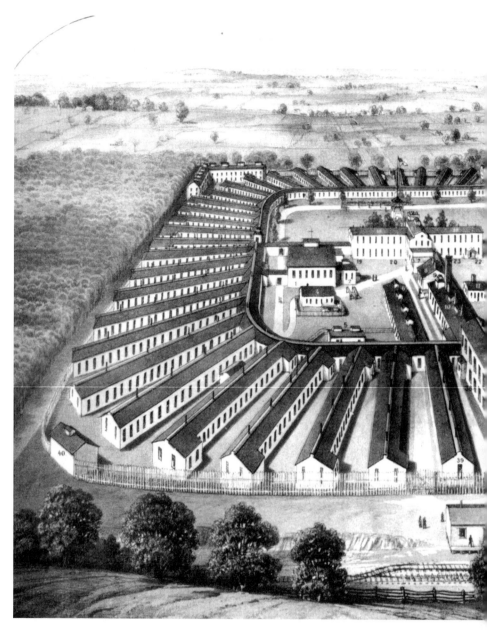

A lithograph of Mower Civil War General Hospital showing the radial arrangement of the wards. *Courtesy of Chestnut Hill Historical Society.*

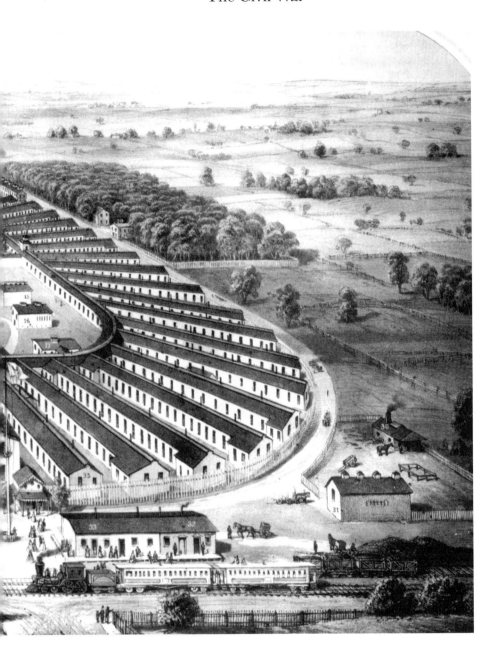

The hospital opened on January 17, 1863, in time for the major battles of the Civil War, including Gettysburg, the Wilderness, Spotsylvania, Petersburg and Richmond. Patients were largely from Pennsylvania, because of a general policy of locating the men as close to home as possible. Wounded from other states, particularly officers, were included because of the vastness of the hospital. The Sanitary Commission maintained a patient file to locate individual patients for their kin.

Mower Hospital was demolished at the end of the Civil War. The hospital lives on in the homes of Chestnut Hill that were built of its lumber; such houses exist today on Devon and Southampton Streets. The bell of the Christ Ascension Lutheran Church at Southampton and Germantown Avenues is dated 1861 and originally hung in the chapel of Mower Hospital. In March 2000, Mower Hospital was awarded a historic marker by the Pennsylvania Historical and Museum Commission. The marker was erected on Sunday, September 17, 2000, at 2:00 p.m., with appropriate ceremony and reenactment at the Wyndmoor train station.

Mower Hospital was a considerable advance in the treatment of war wounds, disease and epidemics. The Army Medical Department created an effective service for the Union army in terms of treatment of battlefield wounds and long-term care of the wounded. The medical records of the Civil War have proved of great value to future generations in the progress of medicine.

Part 4
People of Note

Dr. Christopher Witt (1675–1765), Citizen Extraordinary

By Margaret B. Tinkcom; Crier, *1964*

Among the early settlers of Germantown were several men of remarkable intellectual capacity and wide interests. Of these, Dr. Christopher Witt is perhaps the least known and surely one of the most interesting. Witt, an Englishman by birth, arrived at Germantown in 1704 and associated himself at first with the small group of mystics headed by Johannes Kelpius (1673–1708). It is not surprising that this group, known as the Hermits of the Wissahickon, should have attracted Dr. Witt, for the latter came from an England that was in a state of religious and philosophical ferment. There, in the second half of the seventeenth century, all sorts of ideas were in the air. These ranged from the mysticism and religious enthusiasm of people like the Quakers to the disciplined, intellectual exercises of scientists and philosophers like Isaac Newton. Christopher Witt seems to have touched both extremes in his own career.

His practice of the astrologer's art of horoscopy earned him the title of Hexmeister among his fellow Germantowners, and his translations of some of Kelpius's poems attest to his interest in the ideas of this member of the Wissahickon Pietists. But Dr. Witt was a skilled artisan, as well as a mystic and an intellectual, and Kelpius serves as a bridge between the arcane and the worldly concerns of this extraordinary citizen. Both the occult and the mundane interests of Dr. Witt are reflected in a small oil portrait, painted

by him, which shows Kelpius seated in a wooden armchair before a desk on which an open book is lying. On the wall behind the desk hangs a clock, quite probably made by the same Christopher Witt who painted the portrait.

This clock is one of those called Wand-uhren, that is, a clock regulated by a long pendulum and operated by fifteen- or twenty-pound weights suspended from chains. According to George Eckhardt, author of *Pennsylvania Clocks and Clockmakers*, Witt occupied himself with clock making in the winters, when the weather limited his botanical pursuits. In any event, he is known to have made tall clocks, of which the Wand-uhren were forerunners; tower clocks, which were installed in steeples or on public buildings; and mathematical instruments from about 1710 to 1765.

Christopher Saur, the elder, learned the clockmaker's trade from Witt before setting up as a printer. Another of Witt's pupils was Robert Claymer, or Claymore, who is mentioned as having worked as a clockmaker in Philadelphia between 1765 and 1780. Claymer was a onetime slave owned by Witt and given his freedom by the terms of Witt's will. It is interesting, incidentally, that Witt, with his mystical leanings and residence in a community that produced the first formal American protest against slavery (1688), should himself have owned a slave. Perhaps it was due to Witt's Germantown associations that he provided so handsomely for Claymer's future, bequeathing to the slave not only his personal freedom, but considerable property as well. This property included Witt's land on Keyser's Lane (Washington Lane) with all the improvements thereon, a good deal of household furniture, including "my Great Clock which stricks the quarters," and "all my tools, instruments, and Utinsels, belonging or apportaining to the making of Clocks."

Art and religion, science and clock making all concerned this protean man. Witt styled himself, in his will, "Practitioner of Phisyick," and it was as a scientist, particularly as a botanist, that he was best known to his contemporaries. Among his correspondents was Peter Collinson (member of the Royal Society and friend of Benjamin Franklin and John Bartram), to whom Witt regularly sent plants. Witt also maintained a botanical garden at his home, adjoining that of Francis Daniel Pastorius, in Germantown. Perhaps it was a mutual interest in botany that led Thomas Morrey, "of Cheltenham, gent." to bequeath his microscope to Witt in 1735.

In addition to being a botanist, Witt was, as might be expected of a scientist/clockmaker, a student of astronomy. He described the Great Comet of 1743 and made his own eight-foot telescope for astronomical observations. This is probably the telescope, valued at £1.10, which is mentioned in the inventory of his effects. Witt was also well-known in Philadelphia for his interest in music and for his musical instruments—he may have made the

organ and virginals listed in the same inventory. Music, astronomy and clock making are related arts, since all have time as an essential component, but by no means were all early American clockmakers astronomers or musicians.

Christopher Witt's will clearly indicates one more characteristic of this extraordinary citizen, namely, the breadth of his concern for his fellow men, particularly for those who were less fortunate than he. Witt's manumission of Claymer has been mentioned; his gift of sixty pounds in cash to the Pennsylvania Hospital "towards the Support of the poor in the said Hospital" also stands as evidence of a kindly generosity.

Samuel Harvey (1770–1848) and the Civilizing of Germantown

By Lisabeth M. Holloway; Crier, *1989*

Readers of the *Crier* have met Samuel Harvey II (1770–1848) before in his capacity as president of the Bank of Germantown. Subsequent examination of a folder of broadsides has uncovered evidence of his other interests as a civic leader and reformer of manners and morals.

The Harvey family originated in America with Job Harvey, who settled in Chester County, Pennsylvania, in 1702. Samuel I, Job's grandson, served under Colonel Proctor at the Battles of Brandywine and Germantown, underwent the rigors of winter encampment at Whitemarsh and died in 1778 as the result of that experience. He left a widow and seven children, the fourth of whom, Samuel II, was "kept at school in the summers" until the age of fifteen. "During which time," Samuel says in an autobiographical statement written in 1836, "I learned to read well, write a good hand, cipher through Dilworth's Assistant, learned something of Geometry, Trigonometry, Surveying, Mensuration, Guaging [*sic*], Dialing, Gunnery and Bookkeeping."

From 1786 onward, the young man served a succession of clerkships with ironmasters and storekeepers, at salaries rising from $60 to $600 per annum. In 1796, in partnership with James Worth, he began business as an importer of dry goods and hardware, "retiring" to Germantown in 1813 at the early age of forty-three.

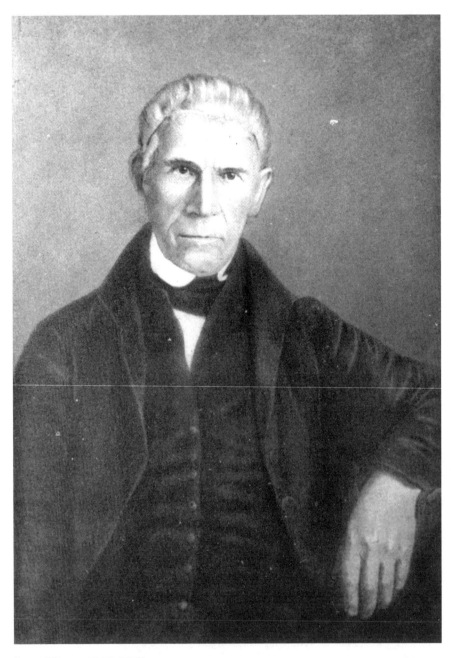

Samuel Harvey (1770–1848).

Indolence, however, was plainly not Samuel Harvey's intent. The next year he became the first president of the newly organized Bank of Germantown. In September 1844, when Germantown held its first election as an incorporated borough, he was elected burgess and was reelected the following year. During his tenure, the roads were well cared for at a modest cost, it is said.

His first wife, Ann North, died in 1813; he then married Sarah Roop and built a house, Rose Hill, which was afterward demolished to clear the site for the town hall. His children included George North (1796–1869); Samuel Jr. (i.e., III, 1799–1884), cashier of his father's bank, a bachelor; Sarah, who married the Reverend James Nourse; and Lydia, who died unmarried in 1898.

Germantown in the first quarter of the nineteenth century would appear to have been somewhat in the doldrums. Few new buildings were constructed; the summer visitors escaping the sickly heat of Philadelphia grew fewer, especially now that the national capital had been established in Washington. Not until after the building of the Philadelphia, Germantown and Norristown Railroad in 1831 would the little village enter a period of new growth.

We have little information bearing directly on manners and morals in Germantown during this period. Certainly the town had families of cultivated tastes—the Haineses, the Wisters, the Chews, the Logans and the Bettons come immediately to mind—but surely, then as always, the population included persons of less refined sensibility. One remembers that the inauguration of Andrew Jackson in 1824 brought to the White House a "disorderly rabble" that celebrated the occasion by putting its boots on polished tables and using fine china bowls as spittoons.

Perhaps Samuel Harvey himself can shed the best light on the state of civilization in Germantown. The Society for the Suppression of Vice and Immorality, of which he was president and Charles J. Wister (misspelled Wistar) secretary, issued a public statement against immorality. Besides this broadside, which has attracted the attention of all Germantown historians, nothing else survives to our knowledge of the society. Quite evidently it did not succeed in stamping out "vicious and immoral habits," because on August 9, 1822, another association was formed with the same object.

Harvey's "Autobiographical Sketch" notes that he "entered into the Methodist Church" in 1795, and in time received "licenses to preach" and was ordained a deacon. The Haines Street Church, founded in 1804, was served in rotation by a "circuit-riding" minister; in his absence, lay preachers conducted the services. Samuel Harvey was one of these. He was also a trustee.

ADDRESS

TO THE INHABITANTS OF GERMANTOWN.

FELLOW CITIZENS,

The Society recently established in this village *for the suppression of vice and immorality,* beg leave to address you on a subject of high importance to the peace of society, as well as the welfare and future happiness of the rising generation.

They have witnessed for some time past, with much concern, a dangerous and alarming prevalence of vice and disorderly practices, especially amongst the youth; of which are, *profane swearing, breaking the sabbath, intoxication, collecting in riotous assemblies, disturbing religious worship, abusing persons and property, pilfering fruit, destroying pasturage and other grounds,* to the great injury of individuals and society in general.

Such vicious and immoral habits, if not seasonably checked, may increase to a degree altogether insufferable, and bring reproach on this village and neighbourhood.

The society, therefore, being deeply impressed with the importance of the subject, have associated themselves together, to suppress, as far as possible, such unlawful practices, and are resolved to use all lawful means in their power to accomplish the same; but before resorting to compulsory measures, they feel it incumbent on them to solicit all parents, masters, and guardians, to use their endeavours to restrain those under their authority from the vices and evils complained of; and while soliciting, the society feel confident the inhabitants, who witness evils so contrary to the principles of the Christian religion, when they consider their destructive effects, and the end to which they inevitably tend, will aid in the proper use of their authority, to prevent measures which might otherwise more deeply affect themselves.

IN BEHALF OF THE SOCIETY,

SAMUEL HARVEY, *Pres't.*

CHARLES J. WISTAR, *Sec'ry.*

Germantown, April 8th, 1815.

Broadside issued by the Society for the Suppression of Vice and Immorality in 1815.

People of Note

From all accounts, Harvey was regarded with affection by all who knew him—business associates, fellow Methodists and the citizenry in general. Occasionally perhaps, like many reformers, he might have seemed a trifle overzealous. And, of course, those who correct others must expect to suffer an extra measure of censure when requiring correction themselves.

This is the only interpretation we can put on the matter of Samuel Harvey's fire buckets, and his remissness therein. The minutes of the Middle Ward Fire Company for February 24, 1820, as quoted by Thomas Shoemaker, record that "the Visiting Committee Report that they found all things In Order except Samuel Harveys Buckets had some grain of Corn in them, whereby he has incurred the fine of five Shillings." (Members of the Volunteer Fire Companies were required to keep two leather buckets hanging inside their front door, one on either side, and never to use them for any other purpose except the fighting of fires. The grains of corn in Harvey's buckets therefore implied that their sanctity had been violated.) Shoemaker continues, however, "At the following meeting he seems to have cleared his skirts of using the buckets for improper purposes, as he was exonerated from paying a fine, though it certainly had a suspicious look."

One of the most persistent annoyances suffered by the landholders of Germantown was the annual visit, on May day, of the volunteer firemen from Philadelphia. Their custom, says Keyser, was to

> *arrive after midnight, get a breakfast at the upper end of the town, and parade home again in the morning, with their apparatus decorated with lilacs, which they were accustomed to gather throughout the town, wherever found, without the formality of asking for them…The Burgess, hearing of an intended visit of the Firemen, notified the constables to be on the alert and arrest any caught stealing the flowers and take them to the lock-up…Mr. Harvey, desirous to know whether his officers were attending to duty, went into his own garden after midnight, when he was promptly seized by the officers, shaken rather roughly, and pushed toward the lock-up, informing him at the same time that he was a scoundrel to steal flowers from the Burgess. After some time he made known his identity, when they apologized for their rudeness, stating that they thought he was one of "them town fellers." He greatly commended them for their vigilance and then retired, blissfully unconscious that they* [had] *fully recognized him from the very first.*

George Washington Carpenter (1802–1860)

Crier, *1986*

By descent George W. Carpenter was a thorough Germantowner. His paternal grandfather Miles came from England, settled in the village and in 1763 married Mary Steer, daughter of Conrad Steer of Germantown. George was sent to Germantown Academy, where he obtained an excellent classical education and a taste for natural history, subsequently improved by his acquaintance with the eminent naturalist Thomas Nuttall. At the early age of twenty-three, Carpenter became an associate of the Academy of Natural Sciences, and at twenty-six its treasurer, his lifelong post. He collected "an extensive cabinet" of minerals and wrote for *Silliman's Journal* on the subject.

At the age of eighteen, he entered the wholesale drug house of Charles Marshall Jr. (a grandson of Christopher Marshall, the Revolutionary apothecary) as an assistant. He remained there eight years, at a small salary, and then took his savings and set up in business for himself. Here his scientific thoroughness and his care in management brought him extraordinary success—"riches flowed in upon him with an undeviating current," wrote the author of *Biographies of Philadelphia Merchants*. One of his most popular products was a kind of "home medicine chest," which accompanied thousands of pioneer families in the South and West, along with his *Medicine Chest Dispensatory*, explaining the use of the preparations. He wrote a text for physicians, *Essays on the Materia Medica*, and also articles for Dr. Nathaniel Chapman's *American Journal of the Medical Sciences*.

Around 1836, he was able to buy a farm in Germantown—in "Beggarstown," to be exact, a term he disliked and did his best to abolish. By degrees, profiting, no doubt, by the example of his real estate–minded father, he accumulated much property in the immediate area and in other parts of the city and county as well. At his death he was said to have owned some four hundred properties. He helped rescue the Philadelphia, Germantown and Norristown Railroad from its early difficulties; he was "a director in six railroad companies, one bank, one insurance company…beside being the executor and administrator of several estates, with his own immense interests to take care of."

He and his first wife, Annabelle Wilbank, had one son, George W. Jr. (1837–1921). In 1841, Carpenter married Ellen Douglas (1823–1900), for whom he named his house Phil-Ellena ("love of Ellen"). They had six children.

Carpenter's death at the age of fifty-eight is said to have been brought on by overwork. His affairs, however multifarious and involved, were attended

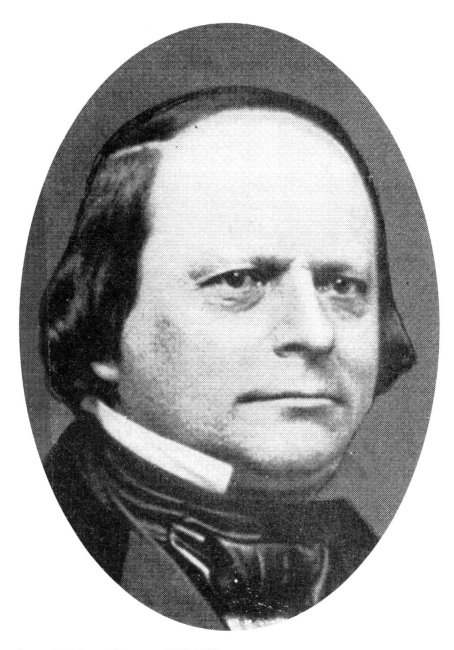

George Washington Carpenter (1802–1860).

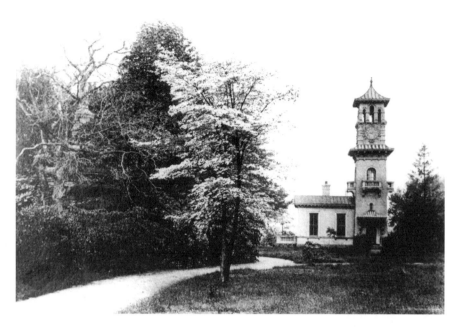

The clock tower on the Carpenter estate, one of the buildings that made up Phil-Ellena.

to daily, and his accounts were posted by nightfall. The principles of business conduct ascribed to him are a model of Victorian propriety:

1. To rise early. He was always up between four and five o'clock in the morning, and did almost a day's work before other people were awake.
2. To employ method and system in everything, whether of study, pleasure or labor.
3. To never undertake any enterprise without being thoroughly prepared for success as well as failure.
4. To purchase for cash instead of credit causes the purchaser to be prudent and careful, and not to overload himself with stock, besides being an advantage in the discount for prompt payment.
5. To go into business entirely upon credit is dangerous, and likely to swamp the young beginner.
6. Never sell to a person who purchases entirely on credit. To meet his payments he will, in eight cases out of ten, be compelled to sacrifice goods for which he promised to pay full prices.

George Carpenter had sixteen years to enjoy his country seat, although it is noted that his intense concentration on business left him too little leisure for the domestic and rural tranquility that he so admired. Thirty-three years after his death, an enormous auction took place of his artwork, his

books and much of his furniture. His widow gave many of his rare plants to Horticultural Hall in Fairmount Park and his mineralogical collection to the Academy of Natural Sciences. The catalogue of his treasures is imposing. What had been Phil-Ellena was demolished, and in a little over fifty years, its splendors came to exist only in reminiscence, in museum collections and in photographs.

A Quaker Grandmother: Sarah Logan Fisher Wister (1806–1892)

By granddaughter Ella Wister Haines; Crier, *1956*

How Grandfather ever met Gram'ma is not recorded. Nothing could have been more different than their backgrounds or ways of life. Gram'ma's extraordinary courage and independence, leading her to relinquish her family and marry William Wister in the parlor of Grumblethorpe, must have been a social upheaval beyond description. Grandfather's Uncle Charles, then occupying the house, brought it about, and the demure young Quaker maiden, abandoned temporarily by her parents, married William Wister and was promptly thrown out of Friends Meeting, bag and baggage. Be it recorded, however, that in later years the Friends softened sufficiently to let her attend Meeting with her six sons. As for Grandfather's religion, we hear little of it. He seems to have been an easygoing young man. His father, born a Lutheran, had become a "convinced Friend" and these were frowned on in the meetinghouse.

Gram'ma was a cheerful soul, with a twinkle in her eye when you caught her off guard. She could also laugh merrily, especially on Sundays when the assembled sons and their wives regaled the long dinner table with funny stories. This weekly affair took place at three o'clock and there were often as many as twenty at table. The food—largely raised in the garden by old Edward Dunn, who lived with his family in the little house at the foot of the hill—was sumptuous. Everything delicious and eatable was raised at Belfield: cows, pigs, chickens and turkeys, as well as Uncle Langhorne's pigeons. Hams, sausage and scrapple were Gram'ma's pride, and after the

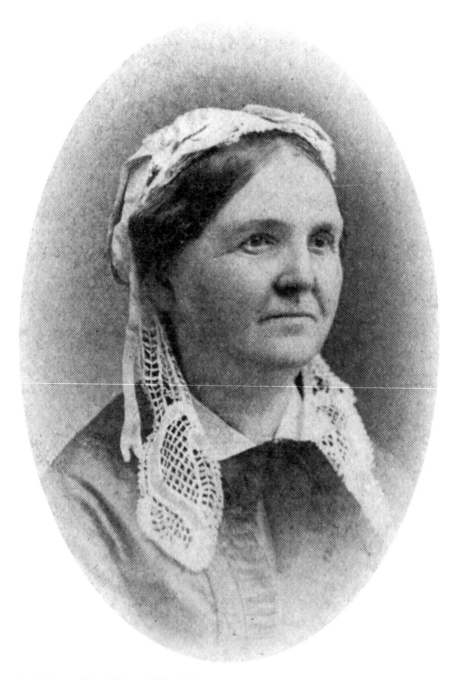

Sarah Logan Fisher Wister (1806–1892).

annual slaughter of the pigs, she personally superintended the preparing of the pork in her basement smokehouse.

Twice a week my Uncle Jones went to the market in town to buy meats. In summer when fruit was plentiful, Uncle Rod came out early on Sundays and churned a huge tub of delicious ice cream.

Be it recorded that Gram'ma had a piano in the parlor, an additional black spot on her character from the Quaker point of view. One story concerning this piano stands out in my memory, and whether I dreamed it or not, as some of the older ones declare, it's worth telling, concerning an afternoon when Gram'ma, looking out the window, saw visitors approaching down the long, shaded avenue and exclaimed, "Children, I see Friend Eleanor Evans approaching. Put the screen in front of the piano." The screen, a nondescript Victorian affair, was only half as high as the upright piano and in no way obscured it. Gram'ma, however, was satisfied with the gesture.

Gram'ma required us to learn things, to read aloud, to sew and by the age of twelve to bake a loaf of bread that must pass her critical inspection. Immediately after dinner we would sit on stools at her feet, reading aloud in turn.

Gram'ma did much dry goods shopping. We would visit the Emporium of James S. Jones and Co., still a leading shop of Germantown, where old Jimmy Jones came personally to the carriage, bringing endless bolts of cotton, calico, linen and gingham for Gram'ma's close inspection. He was a short man with a small pointed beard and wore half-lens glasses, giving him an uncanny look. I never remember going into the store when Gram'ma was shopping, but one of our favorite afternoon walks, later on, was a trip to go all around the big store.

There was another emporium, though not so large, known as Upper Jones, where Mr. Jonathan Jones also delighted in waiting on Gram'ma in her carriage. I marvel now at the patience of these men, for it was Gram'ma's motto to be shown everything in the shop before selecting.

I have since wondered what became of those myriad yards of dress goods. Possibly they went to the Schofield School, or the Germantown Hospital just across Clarkson Avenue on Duy's Lane, where Gram'ma was an active member of the Women's Committee, and in which she took keen interest. I remember being sent through the wards (there were no private rooms) to carry bouquets of lilies and other flowers in season. There was one other possible outlet, a funny little school on Fisher's Lane, below the Wakefield properties, known as Wakefield Infant School. Here young children were trained in the three Rs, carefully supervised by Gram'ma and other worthy souls. Once a year a so-called Strawberry Festival was held, and we were taken to see what

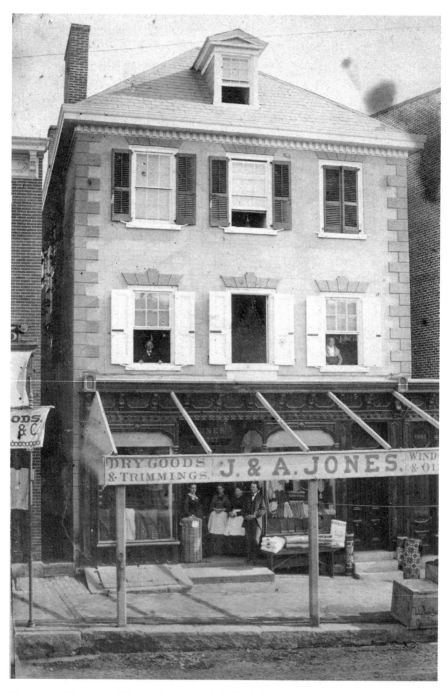

The store of Jonathan "Upper" Jones at 5811–5813 Germantown Avenue. Jones is seen in the doorway.

those little children had learned, and to eat ice cream, cake and strawberries. It must have been in the nature of a graduation ceremony, but all I remember is seeing little girls making up doll beds and tucking dolls away in them.

Our uncles participated in the Civil War, and here again Gram'ma's extraordinary character shines out, for not only did she, born a member of the Society of Friends, consent to her sons becoming soldiers, but she herself assumed a vital part in the work of the Sanitary Fair, which raised funds for the soldiers.

A year before her death, we sat in the Belfield library, while in the parlor lay Uncle Langhorne, in a coffin draped with the American flag. At two o'clock we sat in silence for one solid hour in the extraordinary proceedings of a Quaker funeral for a fighting man.

Less than a year later we again sat in the library. This time it was our grandmother who lay in the parlor, surrounded by friends and flowers. Uncle Jones told the following story of that funeral. Gram'ma's sons, it appeared, were fearful that there would be no preaching or prayers for their mother because she had been thrown out of the Meeting. The idea distressed them greatly but Uncle Jones solved the problem. The funeral would begin at two o'clock. A good friend, Reverend Louis F. Benson, agreed to make a prayer if by 2:55 p.m. no word had been spoken. His services were not needed, however, for at exactly 2:55 p.m. Friend Samuel Morris arose and did it for him.

John Richards (1831–1889) and His Sketchbook

By Lisabeth M. Holloway; Crier, *1981*

In 1854, a plain young couple, John and Esther Richards, immigrated to New York from Switzerland. According to George Clarence Johnson (who probably never knew Richards except at secondhand), Richards, a native of Bern, "was of a freedom-loving nature." Perhaps so; in any case, he was naturalized a citizen, and on May 25, 1861, he enlisted in Company K, New York Fifty-ninth Infantry. He was wounded at the Battle of Bull Run in August of 1862, and again at Antietam in September. He was sent to Mower Hospital in Chestnut Hill to recuperate, and at this time, according to Julius Friedrich Sachse,

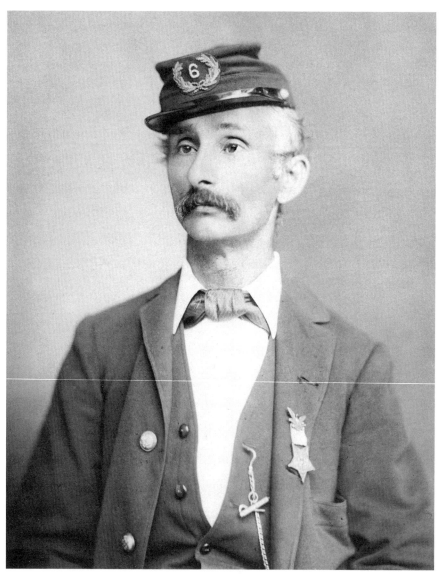

John Richards (1831–1889).

He began sketching some of the old landmarks and buildings of Germantown. From these crude sketches he later made drawings on zinc plates from which an impression could be taken by the lithographic process. Richards's drawings were more or less harsh and lacking in detail especially where he attempted to introduce figures or animals often somewhat out of perspective. At the same time, considering the fact that he never had any instruction in art, these sketches have a merit and individuality of their own. Their chief value, however, consists in the fact that they have preserved to us and generations to come the values and landmarks of historic and quaint Germantown of days gone by.

After the war, Richards settled in Germantown, first as a gardener to the Clemm Estate in Pulaskitown, says G.C. Johnson, and later as sexton of Calvary Protestant Episcopal Church on Pulaski Avenue. He rented from L.C. Baumann, a greenhouse owner who lived nearby, a house on Pulaski Avenue, a little south of Manheim. Here he went on with his drawing. John Hart, a local lithographer who had experimented with the new medium of zinc for lithography, urged him to redraw his best pictures on zinc. Some of the prints were sold, with the aid of the ladies of Calvary Church, and he acquired a local reputation.

His neighbors, however, continued to regard him with apparent condescension—especially Edwin C. Jellett, botanist, archivist and historian, who called him "a queer character, and I sometimes thought him below par mentally…though faithful to his work and in every sense a man to be respected." Richards made some effort to be taken seriously as an artist, says Jellett: "He wished to sketch Mr. Baumann's place and offered to make a sketch for $3. He told me he was disappointed in not being able to secure an order for the work. He wished me to take him to the Old Trappe Church, which I agreed to do…but I could not conveniently go on a weekday and Richards could not go at all on a Sunday." So we have no sketch of the Old Trappe Church or Baumann's greenhouses.

Richards died May 26, 1889, his wife Esther having died April 23, 1879. No mention is made of children. After his death, many of his drawings came into the possession of Horace F. McCann, proprietor of the *Germantown Independent-Gazette*. His sketchbook was presented to the Germantown Historical Society by Mrs. Thomas Evans. From Mrs. Julius Sachse, the society also obtained thirty of the zinc plates.

In 1913, Julius Sachse undertook the editing and publication of sixty of Richards's lithographs and sketches, under the title *Quaint Old Germantown in Pennsylvania: Sixty Views of Ancient Landmarks 1863–1888*. To this writer's eye,

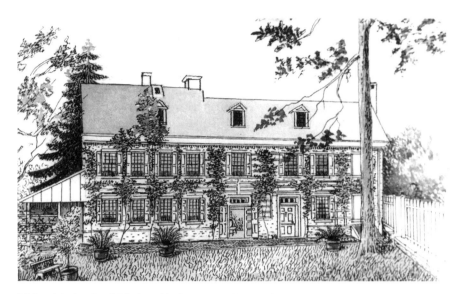

Richards's sketch of Wyck, built circa 1690. It served as home to nine generations of the Wistar and Haines families and is now open to the public.

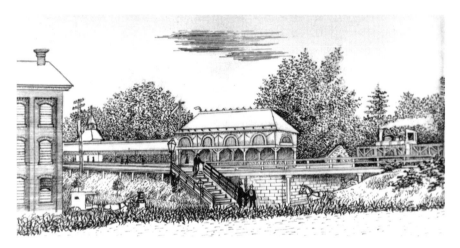

Richards's sketch of Wayne Junction, where the PG and NRR branches off to go to the Germantown depot at Price Street.

in spite of Sachse, the sketchbook far outranks the published lithographs in freshness, charm and historic interest—not only because the lithographs have been so often reproduced in print by Hotchkin, Keyser, Hocker and others, but also because Richards seems to have been much more at ease with the pen than with the lithographer's tools. Most of the drawings are finished with precise attention to shading and architectural detail. A few are merely roughed out in pencil. Toward the end of the book, he occasionally tried his hand at a colored wash, in soft blue or brown.

There are three hundred—perhaps four hundred—views of all kinds, although no portraits to speak of. Subjects include mansions, farmhouses, cottages, barns, streets in the town and lanes in the country, ponds, streams, caves, bridges, railways and horse-drawn streetcars; relics like pistols, a drum, a silver tankard and a German Bible. Often in a doorway will be an old-fashioned country woman in bonnet and apron, or an old codger on the street, a horse and rider, or a couple of cows or a cat on the roof. Sometimes he must have copied sketches of structures long gone. He went downtown to old Philadelphia and drew the statehouse, inside and out, at the time of the centennial; he went to Bucks County and West Chester. But mostly he drew Germantown, and old Germantown in particular.

Here at last we can agree with Sachse: Richards's chief value is that he preserved the values and landmarks of days gone by. Nineteenth- and twentieth-century Germantown had several eminent and dedicated photographers—John Fanning Watson (or his talented assistant, about 1859), John Bullock, Thomas Shoemaker and J. Mitchell Elliott, to mention only a few. Like Richards, they tried to preserve the visual record of old Germantown, but few of them had his opportunities, and none had his eye.

What Richards saw, as a plain man and an immigrant, were the plain beginnings of immigrant Germantown, which some of his contemporaries were busy forgetting. The illustrations show simple, unadorned structures of the early days. Already by Richards's time they were being replaced by the Italianate villas, Gothic castles and Queen Anne mansions that were to obscure the plain country villages begun 180 years before by immigrants rather like John Richards himself.

A Germantown Physician

By Maurice J. Karpeles, MD; Crier, *1962*

Chelten Avenue was a regular boulevard with no stores and very few houses in 1898, when I first put up my shingle announcing to all and sundry that I was a doctor and prepared to take care of their ills. Prior to this day, I'd spent a year or so at the Jewish Hospital, where I'd served my internship. Now, with medical bag and diploma, I was ready to treat the sick of Germantown.

Quite frankly, I hoped that my calls would be from people who lived nearby. I was a poor doctor—just starting out—and the only transportation I could afford was a bicycle. But since I was also a young doctor, I'd straddle my bike and go pedaling off to answer the call, grateful that I'd been chosen.

By a stroke of pure luck, I eventually was able to buy a second-hand doctor's buggy, but still lacked the finances to buy a horse to pull it. Nothing daunted, I rented a horse from the livery stable three days a week and arrived at my patients' homes in true doctor-like style. On other days, my transportation was via the trusty old bike or on shank's mare—but I always got there.

Through affiliation with the Republican Club, I got to know more and more people, and the more people I knew, the larger my practice grew. Eventually, I felt financially secure enough to invest in my first automobile— a Reo, chain-driven, in the latest style. However, this horseless carriage was quite a problem—whenever I needed a part for repairs, it had to come from Detroit and frequently took as long as a month to arrive. I solved the problem by purchasing a second Reo, which supplied me with all the interchangeable parts I needed, and with a capable mechanic to do the work, I was soon spinning merrily along.

How times have changed! I drove my own car up until three months ago. But nowadays I sit back and let someone else do the driving. I'm fortunate to have three retired men alternate the job of chauffeuring me on my calls. This works out fine for all of us—I don't have to fight the traffic at my age, and these men can earn a few dollars a month on the side.

I have so many things to remember, such as the time I accompanied a patient to the Mayo Clinic. The hospital in those days was nestled in the heart of a little country town—so backward that the same piano was moved from place to place on schedule to accompany the action of the "new moving pictures."

And I'm proud to think that I was the first person to congratulate McKinley when he received the presidential nomination. I was on my way home when

the news about this great man reached us on the train. I got off at Chicago and immediately made my way to McKinley's home. I had new cards—M.J. Karpeles, MD, was printed in bold type—and I proudly hauled one out and handed it to the butler. No one was more surprised than I when Major McKinley came out to the porch, sat down and chatted with me until the official serenaders arrived!

I remember, too, how I was always assured of a good seat at the Academy of Music because I was a stockholder. If there were medical emergencies, I took care of them without charge. Now that I am no longer a stockholder, I am still treated regally by the academy. A seat in the left-hand box is reserved for me until curtain time, and if I don't claim it then it's given to someone else.

And close to my heart are the memories I associate with the Philadelphia County Medical Society. I'm proud to say that I founded its first branch here in Germantown. And through my chairmanship of the Life Membership Committee, we raised enough money to purchase our own building at Eighteenth and Spruce Streets.

Of what use would memories be if they didn't include a little romance? I have vivid recollections of my first meeting with May Lang, my courtship of the lady and my marriage to her. We both still enjoy a busy, useful life together and are storing up facts and events that took place not too long ago for our daughter and our grandchildren to enjoy in the future.

There are so many, many things that have been important to me during my sixty-four years in Germantown. Like all my brothers in the Lodge, I was extremely pleased when I was accepted for membership in the Masonic Lodge of Germantown.

Part 5

Neighborhoods

Old-time Neighborhoods, Villages and One-Man Towns: A Gazetteer

Crier, *1985*

As the German village slowly grew into a town, then into a suburb and eventually submerged its identity, at least in part, in the city of Philadelphia, a number of smaller communities came into being within its boundaries, flourished for a time, more or less, and ultimately disappeared. Some of these—especially those with colorful names like Dogtown, Smearsburg and Beggarstown—still arouse curiosity. Others—like McNabbtown, Little Britain and New Jerusalem—survive chiefly in old-timers' vivid reminiscences of fifty to seventy-five years ago.

BEGGARSTOWN (also Dogtown and Franklinville). On both sides of Germantown Avenue, between Upsal and Carpenter on the west and Gorgas on the east. One writer attributes the name to a corruption of Van Bebberstown, after a neighboring family, whereas Hocker theorizes that it came from Bethelhausen ("house of God"), claiming to have found that term in old manuscripts. It is also said to have originated from the poverty of the inhabitants of Upper Germantown. (One story has it that an early inhabitant went around the town collecting money to buy a cow, though actually he built himself a house with the gifts.) Also adduced to support the poverty theory is the extraordinary argument that "Germantown" was mispronounced by Germans as "Yarmentown"—"armen" meaning "poor"

in German. About 1836, a correspondent proposed Franklinville instead, as it appears on the 1849 map, which has "Frankland" Street, not "Franklin," for what is now Hortter. George W. Carpenter, whose writ ran large in those parts, did not care for the term "Beggarstown," says Jellett; however, even his influence could not eradicate it.

In 1927, the *Independent-Gazette* published a list of "oldtime residents of Dogtown" by occupation—"Butcher of hogs," "Cigarmaker," "Carpet designer," "Ventriloquist"—submitted by Milton B. Tyler of Crowson Street, who was, incidentally, the superintendent of the Hood Cemetery, which was in Smearsburg.

The Old Dogtown Band played its one tune, "The Old Grey Mare," up and down Germantown Avenue in the 1860s, its musicians (courtesy title) collecting liquid refreshments as they went. For a time the town went dry, but the band played on, and liquid refreshments were provided as usual, albeit in teacups. Most of the inhabitants, said Tyler, were proud dog owners, especially the Franklin Fire Company on Main at Franklin, which had a "beautifully spotted coach dog," hence the name Dogtown.

BLUE BELL HILL. Near Johnson Street and Wissahickon Avenue, fronting about 450 feet on Wissahickon Avenue and running west about two city squares; named for "the profusion of blue bells which grew in this field." Clarence Jacoby in 1927 recalled schoolboy pranks played on neighbors— shutting the race gate leading to the Rittenhouse Mill, which was then making cotton batting, and defending Isaac Rittenhouse's apple orchard against depredators from Little Britain [Wayne Avenue and Price Street] or Devilstown nearby.

The earliest record of sale for any lot on Blue Bell Hill, according to Jacoby, was in 1867. He identified early householders as Hutelmyers, Foster, Jacoby, Aucott, Henshaw, Evans, Gentner, Rhoades, Green, Bussger and Mollenkopf.

BRICK YARDS. Along Reading Railroad, above Wister Station. Owned by Samuel Collom.

DEVILSTOWN. Less than a dozen houses, says Jacoby, north of Blue Bell Hill along Wissahickon Avenue (then Township Line) near Carpenter Lane. Populated by mechanics employed in the mills along the Wissahickon, which were removed by degrees by Fairmount Park Commissioners during the 1970s. The area is now all or partly covered by Carpenter's Woods.

Neighborhoods

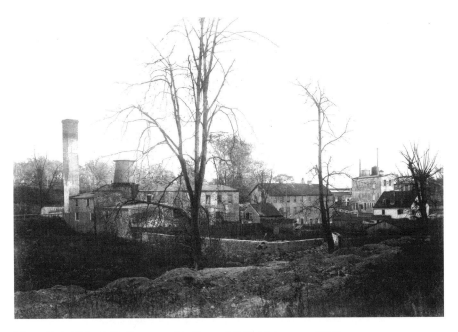

The mills in Fisher's Hollow, near Lindley and Belfield Avenues, 1900.

FISHER'S HOLLOW. Fisher's Lane is now called Logan Street, crossing Germantown Avenue at 4900, and becoming Lindley before it crosses Broad Street at 5100. One of the grid of new streets set out after World War I, Fisher Avenue (originating in Wakefield Park, and crossing Broad at 5300) preserves the name of Thomas Fisher and his family. Their Wakefield Mills, in Fisher's Hollow proper, employed English knitters, some of whom prospered and started their own mills. Locally famous as a beauty spot, Fisher's Station and Fisher's Hollow were often sketched, by Joseph Pennell and Herbert W. Pullinger for example, and photographed, by Edward Hall Sanborn and others. Its noteworthy inhabitants included Septimus Winner, who wrote *Listen to the Mocking Bird*.

IRISHTOWN. Around East Wister Street, south of Chelten, just above Chew. According to Giles S. Stafford, poet and humorist, the sons of the "poor but industrious Irish families" who settled here in the mid-nineteenth century indulged in a good bit of fighting among themselves, and the term "Irishtown" was first applied in some exasperation by Germantown police, often summoned to march more than two miles to the scene of these disturbances. With increasing wealth, Stafford reported, the residents of Irishtown moderated their disagreements and adopted a gentler lifestyle,

preferring the name "Somerville." Newspaper accounts describe balls and other gala occasions at the social clubs of Somerville.

MANHEIM. One of Germantown's early cross streets, running west from what is now 5100, Manheim Street was opened about 1740 by the Shippens and has been called at various times Shippen's Lane, Betton's Lane, Pickus's Lane and Cox's Lane. After 1792, Henry Fraley laid out a tract of small building lots, calling it Manheim Village; these were "quite unexpectedly purchased by people of means from Philadelphia, and instead of a populous village, the lots were consolidated into a few large country seats." Eventually the Germantown Cricket Club (often called the Manheim Cricket Club) occupied the ground. The area also has Revolutionary significance as an encampment of British soldiers on "Taggart's field," south side of Manheim Street, and as the site of the main body of Washington's army, before and after the Battle of Brandywine. Washington used as his headquarters a farmhouse, "ruined by the war" and afterward rebuilt as the mansion Carlton, which was demolished in the mid-twentieth century.

McNABBTOWN. Near Walnut Lane and Chew Street, occupying "about an acre and a half" just east of Washington Lane Station; built by David McNabb in the 1860s, "using material obtained upon the dismantling of the military hospital at Chestnut Hill." One account mentions twenty-nine houses; a *Public Ledger* story, probably in 1916, lists fifty houses: brick, whitewashed frame with red doors and windows, others "long divorced from association with paint." The land was transferred in 1916 to the City Parks Association and later made part of Awbury Arboretum.

PELHAM. Named by the developers, among whom were Anthony J. Drexel and Edward T. Stotesbury, who in 1893 bought the property extending from Upsal to Carpenter Streets and from Greene to Germantown. This had been the estate of George W. Carpenter, Phil-Ellena, built 1841–44 in or just below Franklinville, and the most elaborate and pretentious private establishment Germantown ever boasted. A planned suburban development rather than an old-time neighborhood, Pelham's substantial turn-of-the-century houses remain comparatively unchanged on the winding roads that an indignant contemporary had deplored as a foolish modernity.

PITTVILLE. Haines Street and Limekiln Pike. "An old and quaint village," standing mostly on ground once owned by a William Pitt. Here was a toll gate and a general store, once a part-time post office. Cedar Park Stock

Some of the early houses in Pulaskitown, on Queen Lane between Priscilla and Morris Streets, as seen in 2003.

Farm trained horses, trotters and pacers and had a racecourse. The National Cemetery is nearby.

PULASKITOWN. Near Queen Lane and Pulaski Avenue; name derived from supposed encampment of Count Pulaski on "Taggart's place" during the Revolution. John Richards lived hereabouts and left drawings of the area.

RITTENHOUSETOWN. On Paper Mill Run, near its convergence with the Wissahickon, stood a settlement of millworkers, "mostly English," employed at Ammidown's (the cotton mill that made blankets during the Civil War), at McKinney's Quarry and also at the paper mill itself. They had their own school (averaging sixty pupils), their own volunteer fire company and a Baptist chapel, which flourished from the mid–1860s until 1888. By then the Fairmount Park Commission had removed the mills and most of the houses.

SAWDUST VILLAGE. East of Reading Railroad and south of Fisher's Station; inhabited by employees of Redles' wood turning and lumber mill on Wakefield Street above Wister. It was so called because the workers came home covered with sawdust.

SMEARSBURG. East side, south of Penn Street. Included also Brickyards, Sawdust Village and Fisher's Hollow. So called, supposedly, from the "smeary" faces of its residents, who had to come home from work without benefit of soap and water. Another account, however, attributes the name to the production of "schmearkase," or cottage cheese, by German farmers. The Columbia volunteer fire company, one of the feistiest of the feisty, was always remembered as one of Smearsburg's great glories. Some of Smearsburg's enthusiastic sons enlarged its boundaries to the west side. "All who lived conveniently near the pump [a "healthy" town pump standing on Main Street near Manheim; there was also a pump in Spring Alley that had once been infected with typhoid bacilli and caused an epidemic] were considered Smearsburgers." Dr. Robert Pitfield, a Smearsburger, mentioned Owen Wister, Thomas Gates and Tom Daly the poet (proficient in both Irish and Italian dialect), but gave his warmest praise to "old Bob Hargreaves," cricketer, famous at bat and as bowler, who raised the pride of Smearsburgers to its highest pitch.

Living on West Walnut Lane

By Sophia Weygandt Harris; Crier, *1950*

I have lived on Walnut Lane almost sixty years, five in my early childhood, the others after my marriage. Mother drove out to Germantown to Walnut Lane (to the house now occupied by Dr. Cahall) with me, a baby of three months, and my older sister, that the children "might enjoy the country air." Far-fetched as this may seem today, some of the older generation must remember when the buses left the Reading Station on East Chelten Avenue and traveled to Greene Street, where one turned south to Manheim Street and the other north to Tulpehocken Street, beyond which there was only a house or two.

Another proof that we were on the country's edge was that my little brother, when about eight or nine years old, used to run across Tank lot from our house on Tulpehocken Street to play with a boy who lived in a house on Walnut Lane (afterward Mr. Pardees's). This boy had caught a raccoon in his own yard, and the two boys enjoyed watching the raccoon, the cleanest of animals, dip all his food in water before eating it.

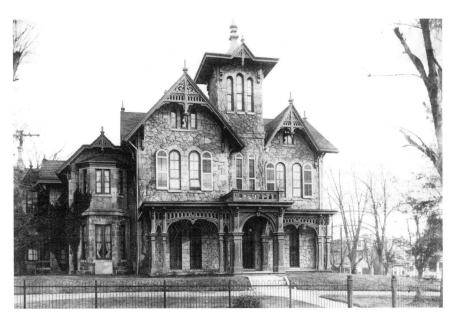

In 1881 this house, designed by Samuel Sloan, at the corner of Walnut Lane and Greene Street was the home of Dr. Thomas Moore, a homeopathic physician.

In those days, omitting School Lane and Manheim Street, where our showplaces were, Walnut Lane and Tulpehocken Street had the handsomest houses on the west side.

When I knew Walnut Lane as a child, there was on the north side only one house between Main Street (now Germantown Avenue) and Adams Street (now McCallum), and that was a house opposite Miss Haines's barn, flush with the street. Between Adams and Greene Street a row of three twin houses was being built. The other homes up to Greene Street were much as they are today, with minor improvements. The gardens were the area of the present gardens. On the south side the houses from Greene Street to the Livezey house (now Dr. Wolf's) were built, or being built. At the northwest corner lived Mr. Needles, next Mr. Kimbles and last Mr. Button, and were always spoken of as the "Needles, Thimbles and Buttons." By the way, Mrs. Button was a direct descendant of the Dr. Priestly who discovered oxygen.

My earliest recollection of the lane is being taken by my nurse to Miss Haines's meadow to gather bluebells by the little stream that flowed through it, under town hall, down to join the Wingohocking Creek. The meadow extended to the wall of the barnyard, and I longed to look over the high wall to see the chickens and cows I was sure were behind it. This old barn of Miss Haines was later made into a very attractive house by Mr. Mantle

Fielding. Later the meadow was bisected by a narrow alley, hedged on both sides, which led to a little court off Harvey Street, where lived many of the coachmen and other servants of the dwellers on Walnut Lane. To youngsters this long, dark alley was a fearsome place at any hour of the day or night, and rightly so, because three or four holdups occurred there.

It was a pleasant neighborhood, this block of Walnut Lane. All living there were friends, liked their neighbors and were very conscious of having left the city far away. One tradition is that the name of the lane came from an enormous walnut tree on the northern border of Miss Haines's property. From the earliest times we were proud that one of the oldest houses in Germantown, Wyck, was at the head of our lane. It had been a hospital during the Revolution, it had always belonged to the same family and it had entertained many distinguished guests, Lafayette among the number. It added grace and distinction to our lane.

Bronson Alcott came to Germantown through Reuben Haines's influence. I recall when I was a little girl, Louisa Alcott came to visit Mr. and Mrs. Francis Howard Williams [in 1882]; and when Miss Alcott said she wanted to meet some of the girls of Germantown to compare them with *Little Women*, I was one of the invited. We all sat on the floor at Miss Alcott's feet and answered and asked questions—a memorable occasion for a little girl!

Facing the lane on Main Street is the Blair House, the summer home of Dr. William Shippen in 1775. His son-in-law, the Reverend Samuel Blair, next occupied it; and it was here the first meeting was held to organize the First Presbyterian Church in Germantown. Dr. Blair was later elected president of Princeton, and was also a chaplain in the Revolutionary army. I vividly recall when Blair House acquired its present portal from an old house that had been torn down.

At an early date Madame Clements established her French boardinghouse and school for young ladies on the south side, west of Greene Street. Her scholars came from far and wide because of the opportunity of learning French, which was the language of the school for boarders always—except in a few classes and for the day pupils as far as possible. I remember seeing the boarders walk two by two down the street, taking their daily exercise and thinking what elegant young ladies they were. Miss Eleanor Clements continued the school after her mother's death, and then Madame Paulin had it for a few years. She was succeeded by Mrs. Richards, who called it the Wellesley Preparatory School, then the Walnut Lane School; and finally it was closed.

In my girlhood, the lane ended at Wayne Avenue. From Madame Clements's school to Wayne Avenue was a field, a remnant of the Haines's

estate cut off from the rest. Corn was its usual crop, and old inhabitants still speak of the golden tassels of the corn waving in the wind every August.

Across Wayne Avenue, at the southeast corner, was Mr. Crenshaw's house, where he lived from 1867 until his death, and his family for years afterward. On the opposite corner, northeast, lived Mr. Samuel Bodine, later president of the Philadelphia Gas Company; and afterward Mr. Peabody for long years.

Across a wide, grass-grown street was a vacant field, and where it met the woods was a turnstile, through which we passed to the Waterworks Woods. The first water for Germantown came from the pond that covered the valley through which the Park Drive now passes. Mr. Henry H. Houston acquired it at an early date and later left it to Fairmount Park. On this pond most of the Germantown children learned to skate.

We again have a school on Walnut Lane, the Stevens School, carrying on the old tradition of education, but the private homes are fast passing away. Doctors' offices and apartment houses are crowding out the homes. We are almost in the heart of the town, but still the wood robins sing their evening song, the woodpeckers tap our old trees and the tanagers stay all winter with us.

Northwestern Germantown

By Gertrude H. Woodward; Crier, *1951*

In our northwest corner of the twenty-second ward, three streets came to an end—Wayne Street [Avenue] and Washington Lane met and abruptly ended; Tulpehocken Street also stopped at Wayne Street, except for the unused road, which led down the catalpa-shaded lane to the old Germantown Water Works and dam.

I well remember one Sunday noon when our nurse took us to the dam to see a baptism. An open space about ten feet square had been cut in the thick ice. A Negro preacher stepped from the bank into the icy water and there baptized about ten Negroes, completely submerging them in the water. This baptism was an unusual occasion, but there was ice on the pond almost every winter and skating was safe and excellent. It was exciting to be part of a long line formed by boys and girls holding hands while a strong boy in the

lead "cracked the whip" and you, somewhere near the end of the line, were swung around almost in a semicircle. I still think the noise of skates on the ice is one of the most delightful of all sounds.

Not only was there skating, but coasting could almost always be counted on in those colder winters. There were many safe hills for coasting, but I remember especially one Saturday my brother took the long "double-runner" sled to Blue Bell Hill and about eight of us spent the morning coasting from the top of the hill down West Township Line (now Wissahickon Avenue) all the way to the corner, where we turned into old Rittenhouse Street and coasted down to the "second quarry." We returned by way of the old bridge near David Rittenhouse's stone house and on up the hill to our starting place. This was certainly before the era of motorcars.

The "Tank Lot" was a high field on the southeast side of Tulpehocken Street from Wayne Street almost to Greene Street. On it had been the high black iron standpipe built to contain the water pumped from the waterworks in the valley below. It was an interesting day to us children when the old landmark was pulled down. This open lot was high above both Wayne and Tulpehocken Streets. Down its steep bank and along its board sidewalk was a lovely wild garden, full of tall Queen Anne's lace and blue chicory

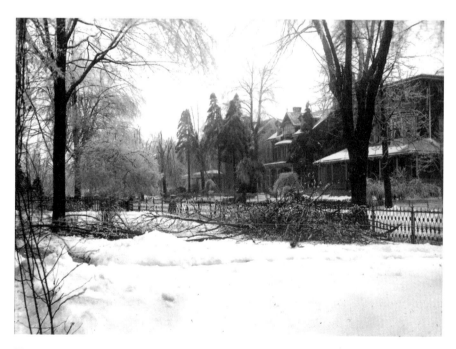

The houses in the 100 block of Tulpehocken Street are seen in 1902 after a snowstorm.

in summer, and goldenrod and wild asters in the autumn. Perhaps the most exciting thing to us about the "Tank Lot" was that it belonged at that time to the queen of Spain, Isabella II.

We lived opposite the west end of this "Tank Lot" and I can think of nothing quieter than the summer Sunday afternoons spent under the trees on the corner of our lawn. Nothing ever went by, Wayne Street and Tulpehocken Street having met and ended. There always seemed to be a delicious cool breeze coming from the west over the green pasture fields and trees beyond. Only one house was vaguely visible beyond the great cherry tree on Wayne Street. This house was most interesting to us, for in it lived Mrs. Bernard Henry (not to be confused with Mr. and Mrs. J. Bayard Henry, who lived in this same house many years later). Mrs. Pauline Henry was the widow of Dr. Bernard Henry, who was lost at sea when he and Mrs. Henry were returning from their wedding journey. She then became an invalid, never getting up from her bed or couch. It was, therefore, very puzzling to be told that Mrs. Henry had "built" the Germantown Hospital. How could a woman who never went out "build" the hospital on the other side of town? All Germantown should be grateful to this invalid lady who began the hospital so many years ago.

Perhaps best of all of this northwest corner was our nearness to the Wissahickon, a joy in spring and summer, a delight in winter when the road was full of fast-moving sleighs. The Wissahickon Drive and Fairmount Park were always lovely. I remember hearing my father say that when he drove to the opening of the Centennial Exhibition on May 10, 1876, almost the whole drive was lined with dogwood trees in full bloom.

The Queen's House (9 West Tulpehocken Street)

Crier, *1962*

A bit of architectural fluff like spun-sugar candy, the house built for Queen Isabella II of Spain stands today in the midst of modern, commercial Germantown.

The queen had commissioned her minister to procure land in America on which a home could be built for her. She had been threatened by nihilists and

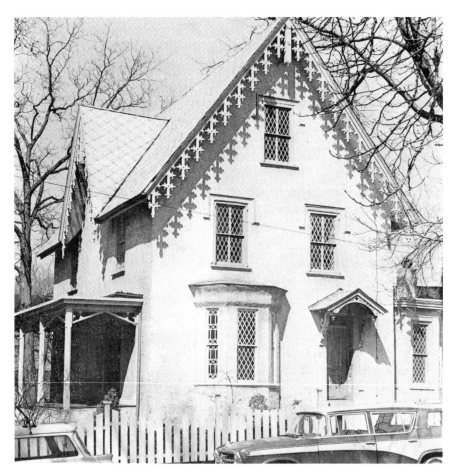

The Queen's House.

had planned to seek refuge from them in this country. However, the trouble was cleared up and there was no necessity for her to leave the throne.

Her minister, J.C. Fallon, invested the queen's money—at her request—in the Germantown waterworks. The house that had originally been built for his sovereign was on these grounds and he authorized using it as a headquarters building for the waterworks.

Completed in 1851, added to in 1875, it has been restored to its former charm by its various owners.

Chestnut Hill in the Gay Nineties

By Randall T. Van Pelt; Crier, *1959*

We lived on the west side of Seminole Avenue, number 8718, between Rex Avenue and Chestnut Hill Avenue. In the early 1890s, on our side of Seminole Avenue, there was not another house on the entire avenue.

Some of the interesting incidents of the 1890s were:

1. The best grocery stores of Philadelphia and Chestnut Hill had representatives call once or twice a week at your residence to take your order. Each representative had his horse and buggy.
2. The Knickerbocker Ice Company had its heavy ice wagons call daily to deliver ice. All the children gathered around the wagon to get some of the ice chips.
3. The hucksters called every day selling fine vegetables, meats and, in season, fresh Delaware shad.
4. The lamplighter, with his ladder, lighting the lamps in the evening, turning them off in the morning.
5. The police officers on their beats. Across the street from our home was a patrol box, where the officer reported. In the night, if awake, you would hear him give his number to headquarters and then slam the heavy steel door.
6. The old English sergeant commanding the children, when coasting was best, "No coasting on the 'ighway!"

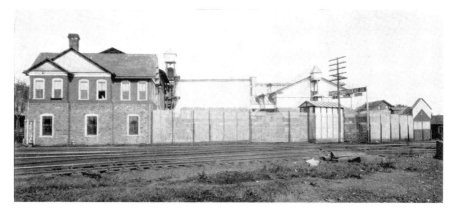

The importance of ice is shown by the size of the Knickerbocker Ice Company at Armat Street and the Reading Railroad in 1899.

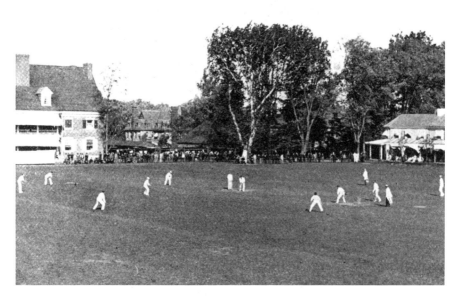

A cricket game at the Manheim (later Germantown) Cricket Club.

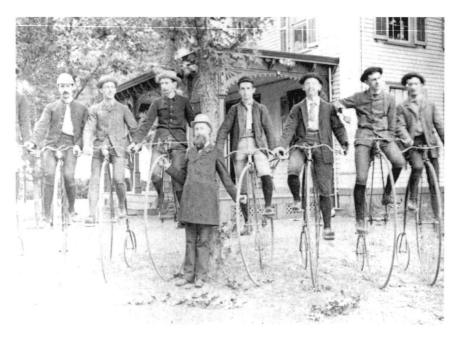

The high wheelers of the Germantown Bicycle Club being steadied by the man at the tree.

7. Old John, the handyman in the neighborhood, was said to use a wheelbarrow to help walk straight when he had had too much beer after his visit to a Main Street tavern.

8. The man, dressed in white linen, carrying his wares atop of his head, calling, "Honeycomb, fresh honeycomb."

9. The trolley rides down Main Street to Philadelphia. They advertised, "The longest and most picturesque ride in the world for 5¢." It was some sixteen miles from South Eighth Street to Chestnut Hill Park, the White City, an amusement park.

10. Trolley parties, brilliantly lighted cars, many lights, to Willow Grove. It was quite a social event to give a party to the Grove—hear Sousa's Band, Creatore, Damrosch, Victor Herbert and see the beautiful fountain.

11. The cricket games at the Philadelphia Cricket Club and at Manheim. The best English teams—Oxford and Cambridge; Lord Hawkes's eleven; Prince Ranji Cingi, an Indian prince, leading a famous team; the great Jessop, a terrific batter; and Dr. Grace—all in competition with the Gentlemen of Philadelphia. Special trains—first stop Wissahickon Heights—large crowds in attendance.

12. The bicycles—single, tandems and other types—riding up Wissahickon Drive. The Twentieth Century Club cycled in large groups.

13. Robert Glendinning drove the first automobile in our neighborhood, one of the first in Philadelphia. Great excitement as it passed by, especially among the children. "Automobile"—what a funny name.

14. The Philadelphia Horse Show, held late in May and over Decoration Day, was a big social event. Special trains, first stop Wissahickon Heights, brought hundreds of horse lovers to the show. Exhibitors from all over the United States and with many local entries, such as Edward B. Stotesbury and the Dobsons. John B. Bratton, a dealer from St. Louis, brought about forty beautiful horses. His tandem, Sampson and Sigsbee, was outstanding. After the show, Bratton had a sale. A feature exhibition was given by the Pennsylvania Military Academy on Decoration Day. Surrounding the ring were many tallyhos and fine carriages. The grandstand and boxes were filled with the fashionable group.

15. The organ grinder with his monkey; the hurdy-gurdy and the little German bands were features of the day.

16. Every day at Highland Station, Junker's famous bread and rolls were sent out by train in time for breakfast and during the day numerous baskets from the Reading Terminal Market arrived, as well as ice cream and confectionery from Sautters.

17. Drinking water was impure. Every year, as a result, there was an epidemic of typhoid fever. Many died of it. The careful families boiled the drinking water or had spring water delivered. Root beer was popular. One could make five gallons with a bottle of Hire's extract, sold at ten cents, boiled in a five-gallon pot of water, sugar and yeast added, then bottled—delicious. Imported waters were also used, such as Apollinaris and ginger ale.

Growing Up on the Carpenter Estate

By Milton B. Tyler; published in the Independent-Gazette, *1929; reprinted in the* Crier, *1986*

I was born in 1859 on the Carpenter estate, now called Pelham, at 57 Franklin Street, which is now 136 and 138 West Hortter Street. The Carpenter estate was a paradise to me, and for thirteen years it was my playground. In the estate there were six good springs of water; four creeks with minnows, mullets, suckers, small crabs, tadpoles, frogs and lizards in them; and two ponds with goldfish, silverfish, catfish, sunfish and water snakes in them. There were many cedar and juniper trees for Christmas trees.

The food I had for lunch consisted of blackberries, strawberries, raspberries, dewberries, sheepberries, elderberries, gooseberries and currants; chestnuts, black walnuts and hickory nuts; honey cherries, black cherries, Mayduke Bullhart and Indian cherries, pears, early apples, chicken and fox grapes; turnips, rutabaga, cabbage, corn and potatoes.

My sports were making and placing water wheels in the creeks; rolling hoops, marbles and tops; making and shooting bows and arrows; making and flying kites; town ball; baseball; football; shinney; quoit pitching; jumping; running jump; standing jump; casting large stones; wrestling; swimming; fishing; gunning; sledding; and skating.

My companions were boys, girls and animals: the rabbit, opossum, gray squirrel, red squirrel, chipmunk and flying squirrel; snakes—water, black, copperhead and garter; birds—the catbird, robin, swallow, wren, salad or yellow bird, bluebird, blackbird, crow, hummingbird, tomtit, meadowlark, peewee, thrush, flicker, owl, oriole, snow bird, hanging bird and woodpecker;

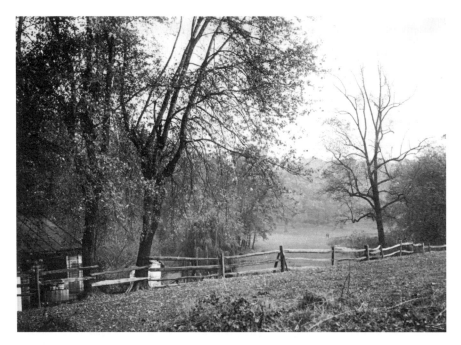

A view of Carpenter's Meadow on the grounds of Phil-Ellena.

with the fields of oats, rye, wheat, clover, timothy, potatoes, turnips, rutabagas, corn and pumpkins.

What is now the northeast corner of Hortter Street and Lincoln Drive was woods to which numerous picnics came during the summer. With these I had many good times, while my clothing was only a hat, shirt and pants. Now, after reading this, do you believe me?

But alas! My paradise has been wiped out and is no more. At 223 Pelham Road and Phil-Ellena Street there still remains part of a chestnut tree, now covered with vines. From this tree I gathered chestnuts fifty-five years ago. It then had a trunk fifteen to eighteen inches in diameter. It bore the finest of chestnuts and many of them. There is also on this property a wooden bridge over a small creek, and the spring that feeds this creek had a dam in it that forced the water up to the Carpenter mansion on Germantown Avenue.

This bridge is part of one of Carpenter's driveways, and over this bridge passed a number of McCallum Carpet Mill employees to and from work each day. The ground on this property southeast of the bridge was a small woods at that time, fifty-five years ago. One winter when the snow had a crust on it, I went down this hill between the trees sitting on my sled. At

the bottom the snow was drifted and my sled broke through the snow crust, stuck fast and threw me in the air and I landed in the creek. I was good and wet.

I had a good straw bed with plenty of warm covers to sleep on. Oh, how I could eat and sleep! I ate cherries, stones and all. I lived, not simply existed.

Part 6

Earning a Living

Trades and Professions in 1838

Crier, *1972*

Before Germantown became a borough in the first half of the nineteenth century, the township authorities were accustomed to make a triennial assessment for taxation purposes of all persons, animals and real estate in the township liable to be subject to tax. The report for January 1838 gives a good idea of the business condition of the time. The amount of land to be taxed was 5,722¼ acres, with 999 taxable inhabitants. There were 486 horses, 633 cows and 487 dogs. In the trades were listed 141 laborers, 139 farmers, 100 cordwainers, 54 carpenters, 48 gentlemen, 36 coopers, 28 storekeepers, 33 hatters, 27 victuallers, 22 carpet weavers, 21 blacksmiths, 18 tailors, 17 teachers, 15 manufacturers, 15 innkeepers, 16 hosiers, 16 wheelwrights, 14 weavers, 13 millers, 12 skindressers, 10 painters, 10 traders, 10 clergymen, 9 coach makers, 9 doctors, 9 calico printers, 8 cabinetmakers, 7 saddlers, 6 papermakers, 6 printers, 6 cutlers, 5 bleachers, 5 bakers, 5 carters, 4 millwrights, 4 dyers, 4 spinners, 4 clerks, 4 soap boilers, 3 coach trimmers, 3 stonecutters, 3 spice manufacturers, 3 students, 3 comb makers, 3 stage drivers, 3 chair makers, 3 watchmakers, 2 plasterers, 2 druggists, 2 curriers, 2 jewelers, 2 tin men, 2 lumber merchants, 1 coachman, 1 plane maker, 1 basket maker, 1 publisher, 1 broker, 1 bottler, 1 umbrella manufacturer, 1 brewer and 1 tanner.

Early Newspaper Routes

By Nathan Marple; Crier, *1962*

Joel Marple, probably the first regular newspaper carrier in Germantown, came from Hartsville, Bucks County, to Germantown in 1842, and soon after started in the newspaper business, serving the morning papers. His office and home were on the south side of Poorhouse Lane—now West Rittenhouse Street—near Greene. At first he covered the entire district himself, but as the business grew and the territory became more extended his eldest son, Amos, was called upon to help serve the lower end, from Chelten Avenue to Wayne Junction, east and west of the Germantown Road. I, the third son, was put to work in 1857, my route starting at Haines Street and ending at Carpenter Street, including both east and west roads. Needless to say, such service entailed a large amount of walking in all kinds of weather.

I remember well an incident of the winter of 1858. One cold disagreeable morning on reaching the Johnson house at Washington Lane—now owned by the Woman's Club—Mr. Johnson was sitting at the front window waiting for me and invited me in to a breakfast of buckwheat cakes and homemade sausage with a big cup of coffee. On my arrival home about 8:30 that morning, my want of appetite at the home breakfast table was easily accounted for. After school hours, it was my custom to sell the afternoon papers at the railroad station at Price Street for Joseph Parker, who kept the store on the opposite corner.

At this time—two or three years before the Civil War started—we were serving about 600 copies of the *Public Ledger,* 150 of the *Inquirer,* 100 of the *North American* and 50 of the *German Democrat.* It was our habit each morning to meet the train from the city arriving at the Price Street Station about 6:30 a.m. The papers, rolled in bundles, were taken by wagon to our home, where the whole family would work at folding them, so that we should be ready to start on our several routes by seven o'clock. I was expected to reach home again in time to have some breakfast and be at the Rittenhouse School by nine o'clock.

When the war broke out, Amos went into the cavalry and the "lower end" route was sold to Robert Cherry. An assistant, Mark Banner, was then employed to help in the central district, which had always been served by Joel Marple. In 1862, I started in another business, which necessitated the sale

of the "upper end" route, until finally, in 1863, the business passed entirely into other hands.

After the war the custom of sending papers out from the city by train was discontinued. The publishers had, up to this time, always paid the expressage, but from 1866 the dealer bore this expense. The papers were sent all over the city by wagon. William Nestor, of Nicetown, is remembered as having the contract for this locality from the *Public Ledger*. The printers at this time also started to fold the papers, making an additional charge to the dealer for it.

John S. Trower (1849–1911) and His Catering Business

Crier, *1984*

Among the Negro entrepreneurs (Dean, Byrd and Trower) who achieved substantial success in Germantown before World War II, only the largest, the Trower firm, carried its success into the second generation. Educational opportunities were scarce, though children of respected Negro families were admitted in limited number into otherwise all-white public elementary schools and into the new Germantown High School without a quota from its inception. Their most respected professions—schoolteaching and the ministry—hardly led to wealth, and middle-level jobs (in the postal and other federal services, police, nursing and the like) were open only on a token basis.

In two areas, however—barbering, hairdressing and personal care; and catering—whites seem to have tolerated and even encouraged black business independence before World War I. W.E.B. DuBois remarks on the "guild of the caterers" who were transformed "by an evolution shrewdly, persistently and tastefully directed from the Negro cook and waiter into the public caterer and restaurateur" (*The Philadelphia Negro: A Social Study*). DuBois gives only passing mention to Germantown, and among his leading black caterers of Philadelphia—Bogle, Augustin, Prosser, Dorsey, Jones and Minton—Trower is not mentioned.

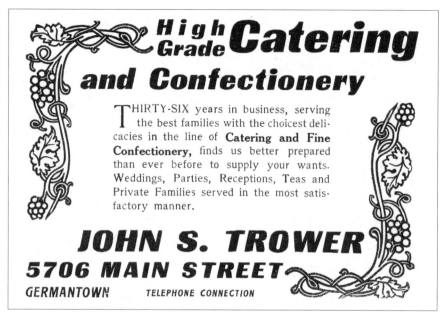

An advertisement for the Trower catering service.

Nevertheless, by his death in 1911, John S. Trower, born on his father's Virginia farm and having started out for himself in Baltimore as an oyster opener, was reckoned as Pennsylvania's wealthiest Negro. He had come to Germantown to work in a taproom; taprooms served luncheon, and Trower supplied food to the taprooms. He sold pies at railroad stations. By 1870, he was in business for himself here; in 1876, he bought for $13,000 the building at 5706 Germantown Avenue, which had belonged to the Saving Fund Society. In 1889, he was named caterer to the Cramp Shipyards, providing "banquets and luncheons at launchings and supplying vessels with food for trial trips." He catered fashionable affairs on dry land as well. He invested wisely in real estate in Germantown and in Ocean City, where his family had a summer home. In Germantown they lived on East School House Lane.

But he did not forget his own people. He guaranteed mortgages and loans to members of his own church, Cherry Memorial Baptist, at Christian and Sixteenth Streets; he financed a black church in Ocean City and Mount Zion in Germantown. He organized a building and loan association for Negroes and he bought 110 acres for an industrial farm for black boys near Downingtown. At his death, his estate was valued at "$150,000 and upwards."

When he died, his sons were minors. As they grew into the business after World War I, they turned the Germantown restaurant into a white supper

club—the restaurant had always served whites exclusively—and about 1925 they closed it down. "Young Jack," as he was always called, eventually returned to catering downtown, acquired the business of a deceased competitor and became one of the celebrated society caterers of the area. Some Germantown blacks came to specialize in the various aspects of his far-flung operations.

The Trower real estate holdings in Germantown were extensive, as began to be evident after Young Jack's death about 1950. When Penney and GSB began to develop the parking lot on the north side of Maplewood near Greene, for example, the property was bought from the Trower Estate. Much other residential property in Germantown also belonged to the Trowers.

The Telephone Exchange

By Loretta Hrycko; Crier, *1962*

The first known Germantown listings in the Philadelphia telephone directory recorded two business and four social (residence) subscribers:

G.E. Atkins & Co./Coal dealers, Armat Street, 9 Gn;
W.L. Clower/Butcher, 4807 Germantown Avenue, 35 Gn;
James Darrach/residence, Greene and Harvey Streets, 14 Gn;
Henry I. Grove/residence, Wayne Street below School Lane, 64 Gn;
Wilson Loyd/residence, 47 Tulpehocken Street, 7 Gn;
H.M. Sill/residence, School Lane and Wayne Street, 65 Gn.

In late 1880, the first Germantown exchange was put into operation. Despite the fact that more and more people were requesting telephones, operators had to remember the names and numbers of their customers. The Germantown office was first located at Germantown and Chelten Avenues, on the site of the present Rowell's Store, and Martha Smith, one of the earlier operators, had many interesting stories to relate to family and friends. A very casual and unusual relationship developed between operators and customers. The "Voice With a Smile" was almost a friend of the family. Every morning the operator would call each telephone user and say, "Good morning, this is the daily test. How do you hear me this morning?"

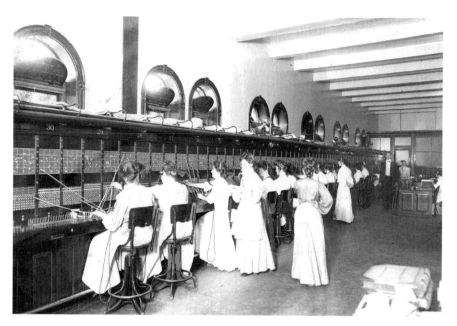

Telephone operators working the Germantown switchboard in 1910.

Streetcars, before "metallic circuits" were extensively used, often caused interference on the telephone line. The talking parties would then ask the operator to relay the message. It was not uncommon to hear an operator repeat, "Mrs. Blank wants a pound of coffee, a dozen eggs and three pounds of flour" and arrange delivery of the order.

One woman called at the same hour each morning and said, "Good morning, Operator. May I have my mother please?" Each operator grew to recognize the distinctive voice and knew with whom to connect her. By 1898, the number of telephone users had grown to four hundred. But even with this ever-increasing group, each operator still knew each subscriber.

The Bell Company, growing larger daily, found it necessary to move to its present location south on Chelten Avenue. The operators' quarters and plant equipment were housed in the basement and first floor. Two additional stories were added later.

Many folks can still recall the early oak wall boxes. How well do they remember that to reach the operator, one turned the crank on the side of the phone and then waited for her to say, "Number please."

Desk-type phones, which stood upright, soon became popular. When the receiver earpiece was lifted, the operator answered. Dial phones were introduced during the Roaring Twenties. Following the upright dial phone

was the small French-type instrument, which was in great demand for both business and residence customers. Before this century was a quarter of the way through, over five thousand people had telephones in the Germantown and Victor exchanges.

Early models of present-day telephones were gradually developed. Before the beginning of World War II, 41 percent of all Philadelphia families and 59 percent of all Germantown families had one or more telephones. There were almost thirty-three thousand instruments in use.

After the war, technological development advanced and Bell Laboratories rapidly switched from war production to consumer supply. New types of telephones were offered in a wide range of colors. And for the first time since the company's beginnings, the sober mien of a black telephone was considered passé. The royal member of the family—the Princess—was introduced in 1960, and has won its laurels as an extremely lightweight instrument in delicate colors, with the added convenience of a night light and an illuminated dial.

Today, by merely lifting the receiver, with a few flicks of the dial a person in Philadelphia can call directly to California; within seconds, a phone is ringing three thousand miles away. Since August of this year, there is no longer any operator interception on directly dialed calls. Each call is recorded automatically by a register connected with every telephone line. The personalized service once offered by the operator is no longer feasible when subscribers number well into the thousands!

With 56,964 instruments in the Germantown and Victor exchanges as of October 1, 1962, and approximately 750 coin box telephones in that area, most people have access to a phone.

Main Street Stores between 1900 and 1920

By Margaret Bacon Bostwick; Crier, *1979*

Main Street (Germantown Avenue) in the early twentieth century, where you met your friends and took all day to shop, was quite different from the avenue we know today. It was a place for leisurely shopping and looking in store windows. There was no need to go to town except for special purchases

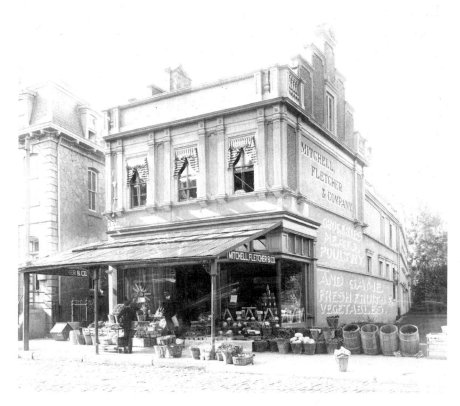

The Mitchell and Fletcher grocery store at 5708 Germantown Avenue in 1906.

or occasions. This is an attempt to recall the names of past stores from Penn Street to Vernon Park, sometimes by the type of business they represented. I hope you will remember pleasant experiences that bring to mind ones I may have missed.

The food stores were the most important and included Pletcher, Ackers, Mitchell and Fletcher, McCray and Hunter and Thomas the Grocer. Best smelling of all was McKinney's tea and coffee shop. As Germantown was always a great place for giving parties, there were caterers such as Harkinson, Rotzell and Trower (the latter was one of the well-known Negro businesses of the area). For sweets, there was Bredenbeck's pastry shop and Asher's candy and ice cream (a retail store then). We were well supplied with four fine drugstores, Smyser and Scott, King of Prussia, Balbernie's and Parrish's. They were real pharmacies and not the small variety stores we have today.

Lower Jones was owned by James S. Jones, who often brought fresh eggs from his farm to sell along with the materials he carried. There was also

Upper Jones (no relation). For shoes and men's clothing, Cherry's was "the" place. If a special suit was needed, Thomas the Tailor could measure the men. Miss Fitler's, the Toma Sisters and Miss Trumbauer were the local milliners. Vant took care of our furrier needs. The ladies at that time had their own special dressmakers to create individual wardrobes.

Of course, one must be beautiful to attend all the parties, so Manley and Arnstein took care of the fancy hairdos. The men and small children with bobbed hair went to Hug the Barber. The name was the cause of many giggles among the small fry.

Now to progress from clothes to household items. There were the two Oestmann's Hardware stores (owned by brothers) a block apart. Darrow's, near Chelten Avenue, sold not only paint but camera supplies as well. Potterton's sold beautiful imported china. I remember well a china cow milk pitcher with the curled tail for the handle and the milk was poured from the mouth.

Carson's supplied the stationery and materials for our desks and for business. Miss Wills also sold stationery. The Step Down Store, run by another Miss Wills, had delicious penny candy. To rival the then "5 and 10 cent" was the "3 and 9 cent" store. The Victrola had come into style, and we could go to Taylor's Music Store or Robert Staton for music and books. The latter's brother owned Staton's Art Gallery. Marple's had some furniture but at Christmastime the windows were full of toys. The wind-up trains kept small boys' noses glued to the window, while the little girls dreamed of things for dolly.

Germantown had good jewelers, including Fischer's with the big clock at the curb and also Enwrights. Mr. Grey or J. Mitchell Elliot took photographs of many generations of families and Mr. Hastings, Kulp's and Berger's supplied the lovely flowers.

We were well supplied with banks—the Germantown Trust Company, the Chelten Trust and the Germantown National. The Germantown Saving Fund was in its present location.

Many of these stores were run by more than one generation of the same family and the proprietors knew most of their customers by name.

The Clockmaker

By Florence T. Reid; Crier, 1964

It was more than fifty years ago [circa 1914], but I remember it as though it were yesterday. I was one of a group of children who walked several miles to school. As we neared Walnut Lane on our way down the avenue, one of us would be sure to say, "Let's hurry so we can see the little men go in and out."

All of us would gather around Mr. Jansen's store, pressing noses flat against the glass and fingerprinting his sparkling clean windows. Our eyes would be fixed on the little shelf off to the side, on which stood a little clock that looked to us just like a cathedral. At an appointed time—probably on the hour and at the half hour—tiny little doors would open and a parade of little figures in multicolored robes would go round and round. We'd stand and watch them so long that the last few blocks had to be raced in order to beat the school bell.

While all of us were fascinated by the apostles on the clock, some found the man facing the window worthy of our attention. He always wore a black cup-like instrument fastened to one eye, a thing that no one else we knew ever wore. He had a long, black beard that flowed down over his chest and side whiskers that added still more to his quaint appearance. And in his hands was usually a clock or a watch, because Mr. Jansen was a well-established clockmaker who also obliged his clientele by mending their broken timepieces.

After all these years, I still can see Mr. Jansen and the wonderful clock he brought with him from Sweden. I'm glad my memory is so vivid, because Mr. Jansen's store was long ago replaced with a different kind of business. Mr. Jansen has been dead for many years and the clock has disappeared. I often wonder if there's somebody else who turns the key and keeps the mechanism in working order so that the tiny doors will open and the apostles will go round and round as they walk. I do hope so.

Earning a Living

Souvenir of Germantown, 1913

Crier, *1984*

In 1913 (the fiftieth anniversary of the Emancipation Proclamation), African American publisher J. Gordon Baugh produced a booklet called *Souvenir of Germantown*. His goal was to show African American progress in Germantown. The following is an excerpt from his booklet:

The Negro population is made up largely of people from Virginia, Maryland and Delaware, although some may be here from several other States. Coming, as most of them did, without money, friends, or anything to depend on except menial labor, and no one to fire their ambition, their progress is good. It is only within the past fifteen years that the necessity for owning real estate has been forced upon them. It must not be forgotten, however, that every family paying rent pays the taxes indirectly.

In the annual report of the Poor Board for 1912 there were 75 inmates at the almshouse, and of that number only three were Negroes.

The total assessed valuation of taxable property in the Twenty-second ward is $87,077,345. The branch tax office estimates that the Negro pays taxes on an assessed valuation of $120,000. It is, therefore, reasonable to assume that the market value is at least $160,000, and it probably cost him more to obtain it.

Eleven churches, estimated value $180,000. (5 Baptist, 3 Methodist, 1 Episcopal, 1 Catholic, 1 Presbyterian).

Four physicians, 2 trained nurses, 1 dentist, 1 real estate agent, 1 contractor, 3 paperhangers, 3 upholsterers, 1 cabinetmaker, 3 printers, 12 dressmakers, 6 hairdressers, 1 milliner, 1 tailor, 3 laundries, 5 barber shops, 3 restaurants, 12 landscape gardeners, 4 bootblack stands, 1 butter and eggs dealer, 3 caterers, 3 coal and ice companies, 3 grocery stores, 2 garages, 4 expressmen, 18 school teachers, 2 post office employees, 1 Custom House employee, 2 policemen, 1 retired policeman, 2 janitors of apartment houses, 3 (branch offices) undertakers and embalmers, 12 fraternal organizations, 2 baseball clubs, 1 orchestra, 3 inventors, 3 second-hand dealers, 1 dramatic organization.

The U.S. census for 1910 gives the following figures for the Twenty-second ward: Whole population, 70,245; males of voting age, 19,529; Negro population, 4,799; males of voting age, 1,205.

The police census for 1910 gives the total population as 70,245, and estimates the Negro population as 11,000. The Police Department does

not claim to be accurate; it is only an estimate, yet there is a large floating population, due to conditions of work, and the police census may have been taken when this population was extra large.

Owing to the difficulty in compiling these statistics there are probably some commendable occupations overlooked. If so, it was not intentional, There are quite a large number of chauffeurs, seamstresses and men and women engaged in doing work in all the ordinary walks of life that any other race is doing. The Delmar, Coulter Inn, and Cresheim Arms are hostelries giving employment to a large number of our people; also Elder's mill, Woods & Logan, comfortable manufacturers, and the Midvale Steel Works employ a large force of our men, some highly skilled mechanics at good wages.

While there may be a number who won't work, the percentage is hardly greater than among other races, and a Negro beggar is seldom, if ever, seen on the streets.

Street Sounds, circa 1920

By Dorothy C. Jones; Crier, *1964*

The screaming sirens of police cars and ambulances frequently awaken me during the night. They make one wonder, are these ear-splitting, nerve-shattering wails indicative of the times? The sounds of my childhood, no longer heard around Germantown, were for the most part happier sounds.

The one that goes back the farthest in my memory did have overtones of Alfred Hitchcock for me. It brings back memories of winter twilights when a sweet, clear, high-pitched female voice would be heard calling "Pepp'ry Pot, nice and hot" over and over. I don't know what there was about that voice, but it chilled the marrow in my bones, and they were very small bones then. My grandmother used to have to put her hands over my ears, otherwise I got hysterical.

About the same time, a male vendor hawked his wares every Friday night by calling, "Crab, hardshelled Baltimo' crab! Fresh crab." His voice didn't "send me," thank goodness.

Everyone wasn't a vendor. Some of these people wanted to buy things. For instance, there was the man who wanted to buy "soap fat." I don't know

A drawing of a typical huckster proclaiming his wares.

what "soap fat" was, but I assume it was renderings. I do remember that children used to taunt him by chanting, "What do you feed your wife on?" Of course, the answer always came back, "Soap fat!"

To get back to the vendors, many of them were seasonal and we heard them only in the summertime. The fruits and vegetables the hucksters hawked are legion but some still stand out among them—"Red ripe tomats, five cents a peck." I know now that a peck is a measure, but when I was little it puzzled me because I thought it was a verb, without knowing what a verb was! "Strawbayries," "watermelones" and of course these were always "red ripe" too, "fraish fish" and "bananas" also stand out. These hucksters had their own dialect. Perhaps it was a hangover from Cockney, as many of them came from Kensington, which was almost 100 percent English.

The sound we children listened for was the Good Humor man of that day. He didn't drive around and ring chimes; he pushed a cart and called, "Ice cream—hokey pokey ice cream." This was the nearest thing to ice milk as

we know it today, but I think "hokey pokey ice cream" sounds much more enticing. I wonder where the "hokey pokey" came from?

Do you like horseradish? If you are my age (and I won't tell it), you'll remember the man who came around and ground it fresh in the glass you furnished. You'll know, too, that the horseradish you buy in the supermarket today is real sissy stuff! You had to approach the freshly ground with caution and respect or you couldn't speak above a whisper for a while.

Waffles were another treat, for a penny, no less. But the gentleman who sold them did not hawk them; he announced his approach with a bugle. I suppose this set him a cut above the hucksters. The waffles were tasty and the penny included a dusting of sugar.

There were other cries of, "Scissors to grind," "Umbrellas to mend," "Clo'es props" and "Any rags today?" I think the rag man was the only one who used sales psychology by adding the word "lady."

I can't let the sounds of yesterday go by without mentioning the German bands that played on the street corners and passed the hat after they had oompahpahed their way through two or three songs. There was also the tinkle of the hurdy-gurdy and the organ grinder with a monkey that tipped its hat and passed a tin cup for his penny.

The police band concerts ranked high on the list of entertainment, but nobody topped the Medicine Man, who stayed as long as three nights. In the light of gasoline flares, he entertained with a banjo, tambourine or mouth organ. He gave out coveted prizes such as ruby glass toothpick holders (I still have one) and then he sold our mothers and fathers the wonderful Elixir of Youth at one dollar per bottle.

The last sound that comes to mind was a winter sound, because somehow I never noticed it in the summer. It was the sound of the factory whistles blowing all over the city at 6:00 p.m., and what an eerie sound it was. To most people it meant the end of a day of toil; to me it sounded like Gabriel's horn, especially the deep basso that was the pride of the Midvale Steel and Ordnance Company. I always held my breath and thought of the end of the world! I'm so happy that they don't blow anymore and look forward to the day when the sirens of today will be silenced in the night when they race around empty streets screaming to clear their path of traffic that doesn't exist.

Part 7
Remember When...

Food and Feasts, circa 1900

By Judge Harold D. Saylor; Crier, *1965*

At Christmastime there was much activity in the kitchen, as cake making took over the household. Sand tarts, kisses made of egg whites and sugar, nutcakes, chewy Scotch cakes much like oatmeal cookies, later on what we call brownies, macaroons of hickory nuts or of black walnuts and, above all, fruitcakes in quantity were the products. Nothing in this line was bought at a shop. Food materials came from the grocery or the nut trees. The cracking of the nuts, the chopping of the citron and the seeding of the large raisins called for work by the children that was made easier by the opportunity to sample the ingredients as well as the finished cakes.

Desserts included charlotte russe (with the right to lick the cream beater); floating island; tapioca in various forms; blanc-mange; cup custard; apple, blackberry, raisin and shoofly pies; and, above all, strawberry shortcake. There was the sweet cake in two layers with beaten egg whites studded with berries on top and then browned in the oven. There was also the true shortcake, a bit sweetened and crowned with whipped cream. The success of either variety was due to the complete saturation of the space between the layers with chopped berries and their juice with a bit of butter and then, on top of all, an overwhelming amount of whole berries. Oh, joy!

Then too there were apple dumplings cooled with milk, sticky cinnamon buns, gingerbread covered with confectioner's sugar and cherry pie, waiting to be cut so that the red juice could run out and sweeten the dough. No pie filler or overdose of cornstarch, such as factory pies possess to satisfy

restaurant trade and avoid dispute as to the distribution of cherries and juice among the slices. Lemon meringue pie had plenty of lemon in the custard, which came out soft and inviting. Our slices were large and not walled stiff with only a suspicion of lemon.

What a loss to a boy's world when home baking went out so generally! Bread was bread in those days. None of this anemic stuff like foam rubber, completely free of the wheat germ that has to be put back in the diet from jars despite the "enriching" of the lifeless bread by the squirting in of vitamins and other artificial rejuvenators of the staff of life.

Liquid refreshment came from lemonade or root beer made on the premises. There were no "bellywashes" of water and sugar and a label, with or without a tax on them. On a hot evening, the block of ice in the refrigerator was scraped to make mounds, into which was poured a fruit juice to provide a cool, sweet refresher.

At Grandpa's house we helped him cut up the fallen apples into schnitz for the winter pie supply, or we gathered twigs and branches for the fire under the great iron cauldron that came into action at the fall butchering or when the soap was made. As the soap cooled, it was cut into manageable pieces to be put on newspapers in the attic to dry out. Not far away were the green Bartlett pears coming ripe under the eaves.

Hams, sausages and scrapple came from the butchering, together with "speck" or bacon slabs. The rind, in time, was good for rubbing on our saws to keep them in trim. The scrapple was full of meat, and not doctored with too much cornmeal. When we wanted scrapple we wanted meat and herbs. Cornmeal came to the table on its own, a golden lot of energy.

Dry breakfast foods were unheard of until Force came on the market. Sunny Jim persuaded us to eat it with sugar and milk to make bone and muscle so that we would be big and husky. It was better than bread and milk, our former hot-weather breakfast dish. While it may not have made blacksmiths or athletes of us all, Force prepared us for shredded wheat and grapenuts and all the other good, dry cereals that in time came to our table.

Memorial Day and the Monument

By Martha R. Nebhut, Crier, *1966*

I cannot remember a year when there wasn't a Memorial Day Parade on Germantown Avenue. It was a tradition in our family and nothing could keep us from Market Square on May 30.

We were very young when it started—this way of celebrating Memorial Day! My mother took great pride in dressing us up in our white sailor dresses with the red-and-blue striped collars, and equally great fuss was made in arranging the huge hair bows, the fashion of the day for little girls. Then up the street we trudged, all five of us, three in sailor dresses and two in sailor suits. This was Memorial Day and we were patriotic! I remember we always managed to get a good early start to be sure of a choice spot in front of the crowd along the curb. Then the endless wait—every so often leaning way out over the curb, peering up the Avenue eager for the first glimpse of the horses that always led the parade. How our excitement mounted as they came slowly closer and closer, until finally they were passing the spot where we were lined up, five in a row! Then came the flags, drums, bugles and the color guards. They seemed so very straight and tall. And the army trucks and tanks and the endless parade of marchers. Line after line they passed, amid the shouts and orders from their leaders.

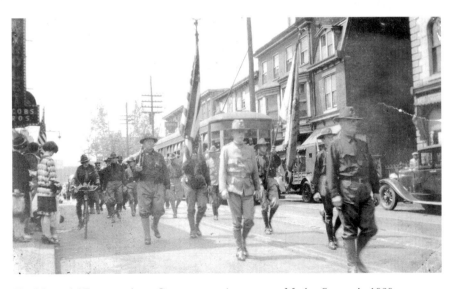

The Memorial Day parade on Germantown Avenue near Market Square in 1929.

And the shouts of the balloon men and the peanut vendors, and the small bands of young "hero worshippers" running alongside, and the bikes decorated with red, white and blue crepe paper. I remember how we put our hands over our ears as the gun salute was fired over the monument in their annual tribute to the men who had given their greatest gift for their country.

And then the hush that settled over the crowd as the beautiful, yet solemn, "Taps" were sounded somewhere down past the Market Square. I remember how it always seemed to get a little chilly when the "Taps" were being sounded; little chills seemed to appear on the small bare arms even though the day was warm and sunny. A long time, and many Memorial Day Parades later, we understood.

The parade was over for another year, but the rest of the tradition that my mother and father had started for us was yet to be relived before we started with our gay-colored balloons (if they hadn't burst by then). Somewhere way up high on the long list of names engraved on one of the plaques around the monument was imprinted our great-grandfather's name. Each year we would climb upon the ledge around the fence and my mother would point out the name to us, explaining that we should be very proud to have our great-grandfather's name on the Honor Roll of the Civil War Veterans. But it was so high and out of reach. Then, as the years started passing, the name seemed to get lower and lower. Soon we no longer had to climb up on the ledge as we showed it off to schoolmates and friends. We could see it now just by standing on our tiptoes. Could they really have lowered the name, or could it be that we were just growing?

I remember this was Memorial Day to us and still is. It just wouldn't be May 30 without the parade on Germantown Avenue and another look at the name on the monument!

Founders' Day, October 6, 1908

By Jane Campbell; published in the Crier, *1982*

Everything possible was done to make the celebration a success. There was a parade of twenty thousand men, in which Indians and German settlers (especially prominent being Pastorius and the thirteen "originals"),

Remember When...

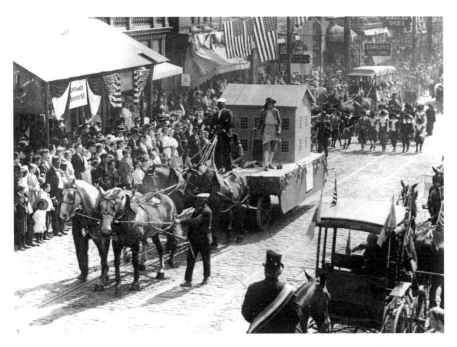

One of the floats in the Founders' Day parade in 1908, the 225th anniversary of the founding of Germantown.

Wissahickon Hermits, an Old Fire Engine and an Old Fireman, Continental Soldiers, Lydia Darrach and George Washington, Gilbert Stuart and Lafayette, General Wayne and Christopher Sauer, the Battle of Germantown and a Wister Party were conspicuous features and made a bewildering historical array of notable scenes and people.

There were all sorts and conditions of associations, clubs and societies, ranging from the Daughters of Liberty to the Grand Army of the Republic, from the Ancient Order of Hibernians to the Improved Order of Red Men, from the Shepherds of Bethlehem to the National German Alliance. There were marshals, captains, reception committees, emergency stations, barrels of ice water, the ringing of school and church bells, the laying of the cornerstone of the Pastorius Monument in Vernon Park, a banquet at Manheim and a lunch at the Museum of the Site and Relic Society, historical leaflets distributed and a "Grand Chorus" and more than 150 Germantown men serving on committees, so many aides to the marshals of the parade that tired nature refused to count them and at least 200,000 people looking at the procession.

The whole town was decorated in honor of the occasion, happy schoolchildren were given a holiday, the mayor of the city came to the cornerstone laying, the president of the United States sent a congratulatory message, there were speeches by distinguished men on the only two available opportunities for speechmaking (the cornerstone ceremony and the banquet) and as one language was not sufficient for expressing a sense of the glories of Germantown Day, two were used, and there were orations in both English and German.

There was an Arch of Welcome erected where Germantown begins. A total of 2,900 schoolchildren were treated to ice cream, sandwiches and coffee in the town hall. Open house was kept at Stenton by the Colonial Dames. Horses, wagons and automobiles were lent by generous owners. Thirty historic sites were marked through the town, the marking being due to the energy and accurate historical knowledge of Mr. Charles Jenkins, president of the Site and Relic Society.

The papers were filled with glowing accounts of Germantown past and present, and dealt out Germantown history to cheer readers in vast quantities. The banks and similar institutions distributed souvenir books and postal cards. An old patent of William Penn's was on exhibition at the Friends' Library. Volunteer guides were asked for so that visitors could be shown the points of interest. The descendants of the "Thirteen Originals" formed the Crefeld Society, electing Dr. J.H. Closson the president. The whole celebration cost something like $3,028.98 and $3,179.75 had been contributed. Surely the Germantown celebration of Founders' Day was a success!

Summer Outings

Crier, *1983*

A vacation is a period of time spent somewhere else. At home, the grass keeps growing and the phone keeps ringing, and the neighbors look askance if one excuses himself from ordinary obligations—in fact, the homebound vacationer is particularly susceptible to extra duties, rather than being relieved of those he normally fulfills. In past times, of course, a proper vacation at

Remember When…

Sixty members of the Germantown and Chestnut Hill Improvement Association meet in June 1924 for an annual outing to Fort Washington. The highlight was a closely fought baseball game.

a distance was prohibitively expensive for many families, and is still so for some. But the day trip, most often to the seashore, provides a change of scene at small expense.

In 1928 the "Man on the Corner," who conducted a column of reminiscence for the *Telegraph,* and without whom we could not conduct this one, encouraged Sergeant Rittenhouse Fraley of the Germantown Police Station to recall some of his past experiences. Fraley said that from 1848 to 1862, "when Atlantic City had not been established," he used to be one of a group of men who made yearly trips to Long Beach, later Beach Haven, hiring a coach and leaving Camden at 5:00 a.m., arriving at the shore sometime before noon. Later, the trip to Cape May on the steamer *Republic* was a favorite trip. The choir of St. Stephen's Church would take its annual excursion in July, round-trip tickets costing one dollar for adults and fifty cents for children, plus twenty cents and ten cents respectively for the train trip from Germantown to the wharf.

Excursions were then, and still are, taken for cultural and social purposes, by persons well able to travel on their own. The Site and Relic Society (precursor of the Germantown Historical Society) and other organizations had annual outings to some local historic spot.

In the 1880s, Henry Bruner's four-horse tally-ho coach made daily trips through Fairmount Park, leaving Germantown at 4:20 p.m. and taking in the Wissahickon Drive, Horticultural Hall and Falls Bridge, at one dollar per seat, fifty cents extra for box seats. Samuel H. Ladley operated "an elegant line of coaches" between Germantown and the Wissahickon at only twenty-five cents round trip. From Riverside Mansion at the mouth of the Wissahickon, passengers could continue their pleasure trip aboard the Schuylkill River steamers.

Beer gardens flourished in the summer. Lorenz Leiling offered "ice cold lager beer" at Indian Queen Park, Queen and Baird (now Newhall) Streets. George Strauss had the Pulaski Avenue Summer Garden on Pulaski below Coulter, again with ice cold beer a specialty. Taylor's Ice Cream Garden, at Wakefield and Jefferson (now Collom) Streets, sold nothing but confectionery and ice cream, but advertised the concerts of the Germantown Orchestra as an added attraction.

Best of all, perhaps, there was sometimes the traveling circus. We do not often wish ourselves back in the 1840s, but if by any chance we should fall through a black hole into a time warp, we could do worse than visit George Heft's Buttonwood Hotel on a September afternoon in 1840:

June, Titus, Angevine & Co.'s NEW AND SPLENDID MENAGERIE OF BEASTS, BIRDS, and REPTILES! Will be exhibited at GEORGE HEFT'S HOTEL (BUTTONWOOD), GERMANTOWN, on Wednesday, September 2, 1840; open from 2 to 6 p.m. Admittance 25 cents, children half price. In the collection will be found the majestic Elephant VIRGINIUS, whose enormous size and unwieldy form renders him at once an object of wonder and amazement; the African Lioness, and the Rhinoceros or Unicorn—this animal was unfortunately killed by the Elephant during the last winter, but has been beautifully preserved, and looks about as well as when living; also the African Lion, the Striped Hyena, the Ocelot, or Tiger Cat; the Royal Bengal Tiger; Coati, or Brazilian Weasel; the ravenous gray Wolf; the Egyptian GIRAFFE, or CAMELEOPARD—this animal was brought to this country alive, from the interior of Africa, but the change of climate being too sudden and severe it died shortly after its arrival in this country, but has been elegantly put up, and looks equally as well as when living; the Zebra, the Jaguar, a pair of South American Tigers, the Arabian Camel, the Peruvian Llama, the Black Bear, the Condor and Ostrich, the Simia, or Monkey tribes.

The pony and monkeys will be introduced into the circle, and go through a variety of extremely diverting tricks.

Also, a pair of LIVING ANACONDA SERPENTS, from Java.
A splendid collection of COSMORAMIC VIEWS! is also attached to
the caravan without any additional charge. In order to render the exhibition
as attractive as possible, the entertainments will also be varied by the
introduction of a variety of COMIC SONGS.

Flying High

Crier, *1982*

Various Germantown balloonists ventured into the skies for fun, but on ballast—no, sorry, on balance, to be sure—we would award Germantown's palm for aeronautical brilliance to one Samuel Custer Eaton Jr., a local boy, an ex-lieutenant in the air service during World War I, who zoomed into our clippings at treetop height on August 11, 1919. He was on his second trip in a plane as aerial postman from Washington to New York and as fate, or coincidence, would have it, or even possibly a little hometown showing off, he was scheduled to pass over his parents' home at 6319 Sherman Street. There were gathered the senior Eatons, with his wife and six-month-old child, awaiting his passage overhead, but all in vain.

Eaton was doing quite nicely, he said afterward, until he got over West Philadelphia, and, according to news clippings, his oil failed him and his Liberty motor began to creak from want of lubricant. As he was over the city, there was no place for the aviator to land, so he decided to continue, hoping to reach Bustleton Field. Meanwhile, he used the emergency hand pump in an attempt to keep his motor lubricated. He flew low and proceeded slowly, working his hand pump all the time. However, over Germantown the motor suddenly stopped and the hand pump failed to give enough oil.

There was no place for Eaton to alight, as he was flying over houses at the time, and the yards and lawns were too small. So he took a chance. Ahead was the big tree—that is, a tall oak tree in the yard of Edward S. Jackson, at 331 West Johnson Street, perhaps 250 yards from his parents' home—and as he floated downward without power, he directed his machine into the tree, carefully holding it so that it would hit only the topmost limbs.

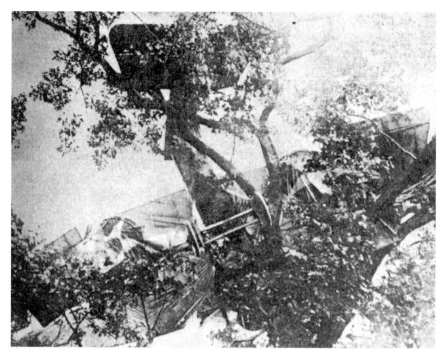

Samuel Custer Eaton's plane trapped in the oak tree at 331 West Johnson Street.

He reached the tree exactly according to his calculations. The branches stopped the plane and held it firmly. However, one of the plane's wings was badly ripped, while a branch flew across the fuselage in such a way that the aviator could not get out of his seat. The tail of the machine flew up and the nose down. There Eaton and his plane hung in midair.

"I'm all right," shouted Eaton to the gathering crowd, "but I can't get out." Someone had sense enough to telephone for the firemen, who came with a truck and raised one of the long ladders. While an interested crowd looked on, the firemen climbed up the ladder and extricated the aviator from his seat, carrying him to the ground amid cheers.

Eaton was not the slightest degree upset by his experience. As soon as he reached the ground, he asked to be directed to a telephone. He called up H.J. Richards, superintendent of the Germantown Post Office, and had him send around at once for the mail bags, which had been brought down by the firemen. With this off his mind, the stranded aviator sat down under the tree, lit his pipe and waited orders, gazing upward at his damaged plane.

The Germantown Community Band

By Norman Giorno-Calapristi; Crier, *2001*

The Germantown Community Band, informally referred to by the Italian community as La Banda Giorno, had its origins in the year 1923. The spark that triggered its birth was ignited by Dr. Amos du Bell, a noted Mount Airy physician and captain in the National Guard 103rd Medical Regiment of Philadelphia, Division 28, in which Luigi Giorno was a warrant officer. The band was formally organized at the request of Dr. du Bell and was composed mainly of Italian-born and Italian-American musicians primarily from the Germantown area. On Giorno's discharge from the National Guard in the mid-1920s, the wartime band continued and transformed itself into the Germantown Community Band during late 1926 and early 1927. This coincided with the establishment of Holy Rosary Italian Catholic Church at Haines and Musgrave Streets, in the primarily Italian immigrant enclave in Germantown.

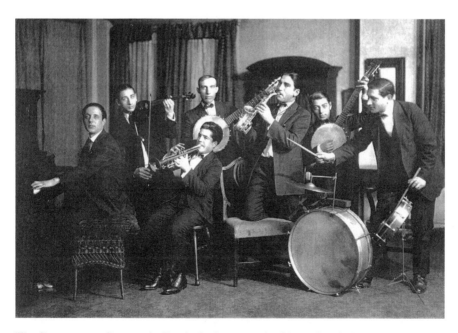

The Germantown Community Band, also known as the Giorno Band, circa 1930.

From that year on, for the duration of the band's existence, the band's association with the liturgical and social life of Holy Rosary parish was sealed. Throughout the forty-two years of its existence, the band was an integral part of the parish, present at every festival and religious street procession honoring the many saints of the Catholic Church. The main event of the year for the band would most certainly have been the annual feast of Our Lady of Mount Carmel, which was held each year for an entire weekend in mid-July.

The band was also present for many funerals. After a funeral service at Holy Rosary Church, it accompanied the cortege of deceased and mourners through the streets of Germantown to the residence of the deceased. This very old Southern Italian custom did not exist in many of the other "Little Italys" of Philadelphia or the surrounding areas. The custom began to wane in the early 1940s and did not survive the postwar years for very long.

On a lighter side, the band performed in the concerts that used to be held in Vernon Park on Germantown Avenue, for the annual Germantown Day celebrations during the 1930s and 1940s and for the many Fourth of July celebrations and fireworks displays held annually at the Waterview Recreational Center at Haines and McMahon Streets.

The war years of the 1940s saw an upsurge in bands as a morale booster to the local populace, and the Germantown Community Band filled the bill here with many patriotic parades through the streets of Germantown, helping to raise money for the national war bond effort.

The band performed not only in Germantown but throughout the Philadelphia area at many of the other Italian parishes of North and South Philadelphia. The band frequently performed at the Italian parish of St. Michael of the Saints on Germantown Avenue, in Lower Germantown. This area was also known as the Brickyard. The band also traveled to Wilmington, Delaware, on many occasions, and to West Chester, Pennsylvania, for similar festivals and celebrations.

Another highlight of the year for the band was the lawn fête held at Ravenhill Academy on School House Lane in the postwar years, and the Medical Relief for Italy charity—both held annually in the Germantown area.

Maestro Luigi Giorno was the band's first and only director. He was born in Italy in 1891 in the town of Luzzi, in the province of Cosenza, Calabria, in the south of Italy. He came to the United States with his parents, Francesco and Teresa Giorno, in 1901. Maestro Giorno's father was a skilled architect and participated in the construction of much of the beautiful stonework on and around Beaver College [now Arcadia University] on the outskirts of Philadelphia.

Remember When…

In addition to his role as band leader, Maestro Giorno also played and taught clarinet, guitar, mandolin, saxophone, banjo and trumpet. Though Maestro Giorno himself had little formal musical training, he was a great teacher and studied orchestration and band instrumentation with Maestro Vincenzo Castaldi of South Philadelphia, a native of Italy, who was also a well-known composer and arranger. Music lessons given by Giorno were generally conducted in English, although a heavy serving of Italian would invariably be introduced as the lessons progressed, so that many pupils commented that they not only benefited musically from their lessons but also linguistically, picking up much basic conversational Italian along the way.

A small orchestra, actually an offshoot of the band known as the Quartetto Giorno, was also quite popular and in demand in the Italian community of Germantown for weddings, christenings, confirmations, birthdays and similar festivities. It was usually composed of two mandolins, a guitar and a bass. On occasion a trumpet or clarinet would be added as the need arose or as the festivity demanded.

"La Serenata," or the serenade tradition, was perhaps the lifeblood of this quartet. It played its many traditional and now very rare mazurkas, waltzes and Neapolitan love songs at the midnight hour beneath the bedroom windows of many a young sweetheart or bride-to-be on the night before her wedding. After two or three musical selections were played by the group, the young woman would turn on a light, signaling that she had accepted the serenade by her prospective suitor. She would then open a window and invite both the musicians and male suitor into the home for a glass of wine, anisette, coffee and some small form of Italian hospitality, such as a piece of hand-sliced prosciutto, sopressata or biscotti. This beautiful tradition held on until the early 1950s, when it went the way of the Italian musical funeral custom—a victim of the march of time, like so many of these ancient traditions.

The Germantown Community Band continued to perform in Germantown at Holy Rosary Church for the now greatly reduced annual Feast of Our Lady of Mount Carmel right up until 1962, the year of Maestro Giorno's death. A bit of recorded music and film footage of both the Germantown Community Band and of the Quartetto survives to this day, preserving the legacy of the Germantown Community Band for generations to come.

My Family and Community

Louetta Ray Hadley; Crier, *2002*

As I reflect on historic Germantown, fond memories emanate. My childhood revolved around this thriving community, which later became a haven for blacks migrating from the South in the 1930s.

My maternal grandfather, William Byrd, migrated to Philadelphia from Virginia in the latter part of the nineteenth century. He owned and operated a stone quarry and became a respected businessman. He was one of the founding members of Mount Zion Baptist Church and the first Sunday school superintendent. Stones from his quarry were used in the building of the church.

My parents (Louetta Byrd and Artis Ray Sr.) met in the Mount Zion Baptist Church of Germantown and married there. Needless to say, the

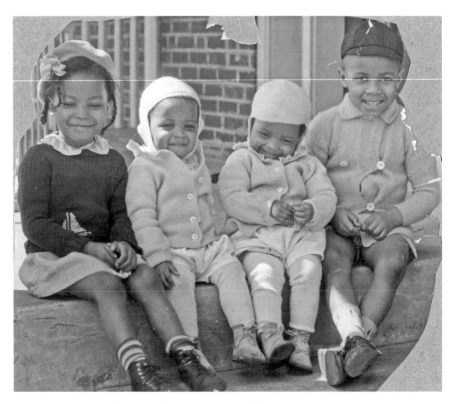

From left: Olga, Louise, Louetta and Artis Ray, children of Artis and Louetta (Byrd) Ray. *Courtesy of Louetta Ray Hadley.*

church became the hub of activity in politics, social actions and, of course, religion. Reverend Morton Winston was the founder of Mount Zion and its first minister, and, incidentally, performed my parents' marriage ceremony.

From this union came my brother, Artis Jr., my older sister Olga, my twin sister Louise and myself. Growing up in the not-always-peaceful 1940s was a task. However, with our parents and a strong community of friends, we were shielded and protected from most of the ugliness in the world around us.

Out of the myriad activities of the church, politics seemed to evolve as one of the most important—many members became Democrats and some Republicans. My great-uncle, Joseph Paige, the professional photographer for the church, became a Democrat, along with Arthur Baylor. However, William Byrd, my grandfather, became a Republican. They became leaders in the community and engaged in many lively debates and discussions in the church and our home.

Most of us went to neighborhood schools—Emlen Elementary, Roosevelt Jr. High—and for high school Germantown High School. We had our fiftieth anniversary celebration last year. Looking back, I realize that blacks and whites went to school, visited and played together. It seemed like a rich social environment in which there were always many varied activities in the churches, the colored YMCA on Rittenhouse Street, the YWCA on Germantown Avenue (now the Settlement School of Music) and the Wissahickon Boys Club. A group of black men who were tennis enthusiasts played at the Colored YWCA. They sponsored tennis tournaments each year and, since hotels were segregated, the players stayed in our homes. One time, we were privileged to have tennis great Althea Gibson stay with us.

Cultural enrichment was paramount in our family. Our parents enlisted Mrs. Kate Taylor, whose husband, Professor Leo Taylor, was the world-renowned organist at Mount Zion, for vocal lessons (we were called Les Jeunes Vocalistes). Her sister, Nora Waring, handled the choral speaking. Mrs. Louise Robinson was the piano teacher. The church became the hub of cultural enrichment. We were encouraged by Mrs. Charlotte Ross, an elementary schoolteacher with the Philadelphia School District. Marie Johnson was our Sunday school drama teacher, Marguerite Gant a choir soloist, Bernice McCaskill Newsome our Bible Study teacher and Mrs. (Helena) J.Q. Jackson our Brownie and Girl Scout leader. These were just a few of the wonderful and caring people mentoring us young people. Louetta Byrd Ray, Ada Byrd, Bertha Ray, Adella Byrd Harper and Jessie Ray Hartwell are a few others.

I particularly remember well the Fourth of July celebrations at Cliveden Park and the Drum and Bugle Corp from Charles Young Post #687

marching to the Veterans Cemetery on Haines Street and Limekiln Pike. Here we placed flags on the soldiers' graves. Later we returned to Cliveden Park for a full day of fun, games and refreshments. Douglas Political Club, 106 East Sharpnack Street, under the direction of Mr. Joseph Paige, provided all the goodies. The clubhouse was a place for adults to discuss issues relevant to the community. I was told that the Masonic Lodge Star in the East #55, 81 East Sharpnack Street, was built with bricks by the hands of its founders. William Byrd Jr. was one of the founding brothers.

While there were many socioeconomic differences—some of our classmates rode in chauffeur-driven limousines, others lived on Lincoln Drive on the west side—we were very happy children. The prejudice that existed in the South was also evident in Germantown in the 1950s. One story that was told at our family gatherings was about the KKK cross burning in our backyard at 319 East Upsal Street in the late 1920s. We were told that our grandfather, William Byrd, along with Tom Dixon and his brother Chris and William and Nathaniel Byrd, all had to be stationed in the backyard with shotguns at night to scare the Klan away. Although this was before I was born, this story is true and often repeated.

On the other hand, so many pleasant memories of beautiful Germantown as I was growing up come to mind—such as working with my father at his business Ramo Barber and Beauty Supplies Store—that I realize now how fortunate I was to have lived as I did. My father was a manufacturer and distributor of beauty supplies, which he delivered to local barber and beauty shops. He also had two stores, one in North Philadelphia and one on Germantown Avenue opposite Vernon Park.

Most of us went on to college, married and are able to see our children grow and move into successful, productive and happy lives. Without romanticizing, most of my memories of growing up in Germantown are happy ones.

Please visit us at
www.historypress.net